M000250517

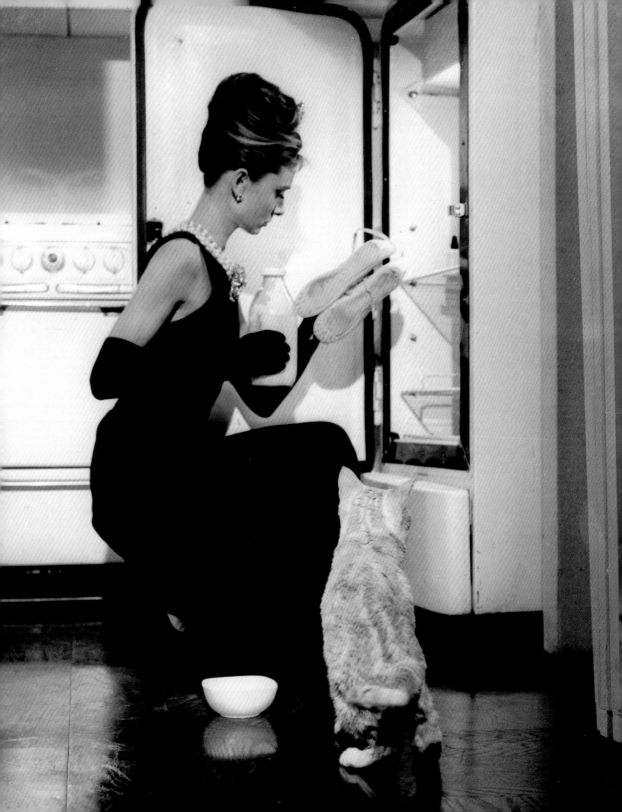

Hollywood Cats

Photographs from the John Kobal Foundation

Edited by Gareth Abbott

ACC ART BOOKS

Gareth Abbott

Pepper the cat, 1912

When a tiny grey cat emerged from underneath a stage at Mack Sennett's Keystone Studios in 1912, who would have guessed that a star to rival some of the great names of the silent era had just been discovered? Stories of chance encounters and fortuitous meetings are legion in Hollywood and have provided scriptwriters with precious material since the first single-reel film was in the can. Yet it was an example of life imitating art that captured the imagination of a film-loving world and thrust a young kitten into the Hollywood spotlight. Pepper, as she was to be christened by Sennett, may have been the first but was by no means to be the last feline artist to earn the respect, admiration and love of both studio executives and audiences alike.

Perhaps we should not be surprised that Sennett's instinct was to carry on filming when he first saw this young kitten appear. Regarded as the greatest innovator of slapstick comedy in film, intuition must have told him that Pepper had a star quality that would not only leave a mark on audiences of the day, but would also secure her a place far above the mere footnotes of any cinematic history that attempts to analyse what made the Hollywood film industry so successful in the first decades of the twentieth century.

Sennett famously was often as silent as his films when pushed by the press to comment on his own work. Yet when it came to

talking about his animals, he could be vocal. In 1919 he released *Rip and Stitch: Taylors* – when asked for his opinion of the film he neglected to mention any of its human stars and went on to single out Pepper as the real reason he imagined the film would achieve success. She was, he said, "the most remarkable animal ever seen on screen".

There were an impressive number of animal stars in the silent era. Not just cats but also dogs, lions, monkeys, elephants, parrots, horses and any number of other species that could find a part to play in the dozens of short films that were produced every month. Pepper could lick cream off her paws on command and play checkers, but then Teddy the Great Dane could drive a train, and Josephine the monkey could play pool and golf. With studio contracts and the potential to earn sums equal to those of their human co-stars, it was no wonder that animals (and their trainers) were ever present. Cats, however, had something of a unique place within this menagerie.

Hollywood was born out of wilderness. It was the desert of California that provided the footprint on which the early soundstages and studio offices were built. It was the natural habitat of strays and when the studios were built they became the playground of these homeless interlopers. Perhaps surprisingly, they were more than tolerated, in-fact they were welcomed.

Hundreds of kittens must have been born over the years – some, like the young cat that sits on Marlon Brando's knee in a famous scene from *The Godfather*, found themselves a place in cinema history, but most simply lived out their lives within the confines of the studio lots untroubled by dreams of stardom. The following pages contain a multitude of images of stars with cats that lived on studio property. Elizabeth Taylor, Ava Gardner, Lilli Palmer, Arlene Dahl and Cary Grant are all photographed with nameless cats who roamed both on and off set with no fear of eviction. Feeding stations were dotted around the properties and we are lucky enough to know (thanks to the surviving press releases that accompanied many of the images in this book), that strong bonds were often formed between the cats, the stars and the studio staff.

In 1929 Maurice Chevalier arrived in Hollywood from France and was promptly photographed with Puzzums. It had become obvious by now that owners and trainers of cats could experience the vicarious thrill of Hollywood through their pets. Nadine Dennis had grown up, like any number of young girls, with a dream to become a star of the screen. A truly successful career in front of the cameras eluded her, but when in October

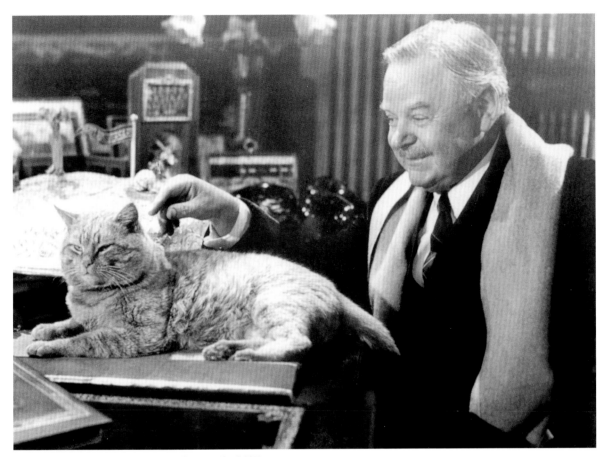

Orangey playing Rhubarb alongside actor Gene Lockhart, 1951

1926 she came across a small stray kitten outside her bedroom window, she had unconsciously discovered a barely imaginable route into the world of which she had dreamed for so long.

Puzzums possessed many of the qualities required from a cat in order to be successful on screen. Besides being able to cross his eyes on command, he could stay focused for long periods of time, had a relaxed demeanour and an ability to get along with not only strangers but other animals too. These were the qualities that got him noticed when Dennis acted on impulse one day and made the trip out to the Sennett Studio. She was immediately offered a contract for Puzzums worth $50 for the first week, rising to $250 a week by the end of the three-year term.

The days when Puzzums and his surrogate mother, a Persian named Ko-Fan, used to accompany Dennis on her rounds of the studios whilst she looked for bit parts in inconsequential productions were over. The two cats that used to sit patiently on the sidelines waiting for her to finish filming now became used to a very different lifestyle. So rich were the rewards that, by the early 1930s, Dennis had given up all intention of striving for stardom herself.

The fan magazines of the day were full of their story. With an insatiable appetite for news of their favourite stars, editors and publishers were only too pleased to feed a film-loving public with photographs of their favourite feline artists. Long and elaborate features were written and mock interviews given professing to represent the true feelings of the animal. It was not unusual to read articles written in the first person in which the cat discussed, in the manner of an autobiography, his or her rise to stardom, what they enjoyed most about working in the industry and their feelings about their co-stars. The readers lapped it up and it is not difficult to imagine articles being glued into scrapbooks and stuck onto bedroom walls.

Pepper's and Puzzums' screen work would undoubtedly

have been recognised by Hollywood had there been an award to acknowledge the contribution they made to film. Alas, they were born too early and died too young to live in the era of the PATSY award. An acronym for Picture Animal Top Star of the Year, the award was conceived in 1939 by the American Humane Association following the death of a horse on the set of 20th Century Fox's *Jesse James*.

For some undetermined reason the first actual PATSY was not awarded until 1951 (when it went to a mule) and we had to wait until the following year for a cat to take the top honour. Then the lucky cat was Orangey, who starred as Rhubarb in the title role of the eponymous film.

Orangey is the only cat to have won the top PATSY award twice. His second was for his role as Holly Golightly's 'Cat' in *Breakfast at Tiffany's*. It was undoubtedly the pinnacle of his career, but the feeling that this red tabby was tolerated for his talents rather than genuinely liked by either his co-stars or the studio crews is difficult to escape. Branded as the 'World's meanest cat' by one studio executive, he displayed remarkable patience in front of the camera and took direction well, but once filming ended he turned into a spitting and scratching tiger. His trainer, Frank Inn, even took to posting guard dogs at exits to prevent Orangey from fleeing and shutting down production until he could be found again.

The irony of the PATSY awards are, of course, that the beast who pads away with the prize on the night may not have been the real star of the show at all. Orangey may wear the crown but no less that fourteen cats were used to portray Rhubarb during filming, each one of them trained to perform a different trick. When Syn won his PATSY in 1966 for his portrayal of DC in *That Darn Cat*, he was one of countless look-alike Seal Point Siamese cats that appeared in the film, and when Jackie the lion took the first of his two awards for his role in *Fearless Fagan*, it went unmentioned that Fagan had actually played himself for the majority of the film. Jackie was merely a stand-in who was used to film certain sequences that were beyond Fagan; whilst tame, the latter was not as well trained as the famous MGM lion.

The art of training cats for the cinema was not for the impatient – it was at times painstakingly laborious. Whilst some cats were expected to do little more than appear comfortable in whatever surroundings they were placed, others were required to perform tricks. Whitey had an array of impressive skills that, by 1935, had earned him a contract with RKO worth $125 a week. Yes, he was happy to lounge quietly in a chair or on the floor as he did in *Alice In Wonderland*, *Village Tale* and *Chasing Yesterday*, but he was also able wash his face on command (as he did in Universal's 1933 production of *The Invisible Man*), as well as lie down and play dead, hang limply over an arm, climb to the top of a ladder and curl his paws under his body to paint a picture of contentment. Each of these tricks took over two months of training on a daily basis to perfect, and were fine-tuned by Whitey's trainer Henry East, aided by the knowledge that this particular feline thespian would have given up eight of his nine lives for a spoonful of ice-cream.

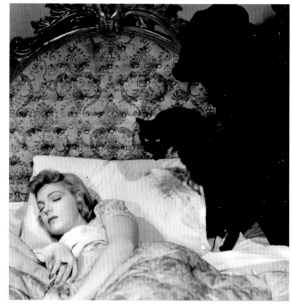

The Black Cat, 1941

Whitey was only the second cat in Hollywood to have a permanent stand-in (the first was Puzzums). When Betty Grable was photographed with Whitey in 1935 outside an RKO sound-stage you can be certain that his double would not have been far away undertaking the menial tasks that couldn't possibly be expected of a true star. Like his human counterparts, Whitey declined to tire himself out posing for long periods whilst the camera and lights were being arranged in readiness for shooting. Often he refused to leave his paw-print on the publicity photographs that were requested by the sackful by adoring fans, and he certainly never allowed himself to be chased by a dog when the script demanded it. All of these duties had the appearance of being a burden and were left to an impersonator.

In some ways, film has proved itself to be no different to any medium that concerns itself with the art of storytelling. At the behest of scriptwriters and directors it constructs scenes and scenarios using an archive of cultural symbols that reflect the current order of things. It may seem far-fetched, but the truth is that cats were often selected for roles with all of the care that a director and producer would reserve for casting a human in a lead role. Henry East, for example, kept up to thirty cats on his five-acre ranch outside Hollywood and could provide a comprehensive variety of breeds according to the needs of the script. Siamese cats were used for exotic sets, Manx for oriental films, Persians for wealthy homes, black cats for horror films and plain alley cats when a stray was required.

Black cats have been blamed throughout history for all

manner of disorder and turmoil, and whilst the idea of the cat as the witch's familiar has its origins in Britain, Hollywood was not indifferent to casting a cat that could truly get lost in the shadows as a symbol of fear and loathing. In 1934 Universal released *The Black Cat*. Starring Boris Karloff and Bela Lugosi, it was an early example of the satanic cult film. The film alludes to Edgar Allen Poe's classic horror tale of the same name without actually referring to anything in it other than the black cats that appear occasionally to strike fear into Lugosi's character. As with so many films that preceded it, and those that followed, the title alone can be seen as a nod to the weight of the symbolism that resides with this particular beast.

Hollywood Cats, however, is not just a record of those feline friends that found themselves in front of a movie camera – it also provides a glimpse of the stars with some of their adored pets. For every Pepper or Puzzums, there was a Joan and a Jinx, beloved companions of Dolores del Rio and Eartha Kitt respectively. Marian Marsh had Precious, Jean Harlow had His Royal Highness and James Mason was so devoted to his cats that in 1949 he and his wife Pamela co-authored and illustrated the book The Cats in Our Lives. Told through amusing and sometimes touching anecdotes, it was, as the title suggests, a tribute to all of the cats the actor had known and loved.

In the minds of the adoring public it was often difficult to separate the star from the cat, so frequently were certain celebrities photographed with their pets. Vivien Leigh's house was overrun with cats (at one point she lived with sixteen) and she was so regularly snapped with certain members of her 'family' that they became almost as well known as she was. Kim Novak bonded so completely with the Siamese star of *Bell Book and Candle*, named Pyewacket (another winner of the PATSY award), that she adopted the cat and they seemingly spent a large part of the next few years being photographed together.

The choice of a Siamese cat to play Pyewacket was an interesting one. It was a departure from the traditional use of a black cat in the role as a witch's companion and is an early example of Hollywood feeding directly into a contemporary trend. By the1950s the choice of pedigreed cats in America was typically limited to only six: Abyssinian, Burmese, Manx, Persian, Siamese and Domestic Shorthair. All were popular but none were coveted as much as the Siamese. The following pages bear witness to the popularity of the breed – its association with royalty as much as its nature helped to make it the most photographed of cats in Hollywood at the time. All of this was in spite of a film industry that was, at times, happy to reflect an anti-Asian prejudice associated with World War II and Korean War propaganda, via the casting of the breed as sneaky, treacherous and sly. Walt Disney was particularly culpable of this when 'casting' the two troublesome Siamese cats in his animated yarn *The Lady and the Tramp*.

Not all of the cats in the book are known – some are nameless props of no distinct breed or origin, often brought in by publicists and photographers to humanise the stars or present a softer side of a contract player hitherto unrecognised by the film-going public. Hired from one of the numerous animal trainers for the day, or even an hour or two, they were a part of the machinery that churned out countless images for the myriad of publications that demanded both original and charming material.

In digging deep into the extraordinary trove that is the John Kobal Foundation Archive for the images that are included in this book, one thing gradually became obvious – the overwhelming number of photographs in *Hollywood Cats* were going to be of women (interestingly this is in contrast to *Hollywood Dogs*, the companion volume to this book). Whilst the archive is made up of an incalculable number of original negatives and prints, as well as interviews with photographers and other material that may have shone a light on this particular peculiarity, it did not offer up any concrete evidence as to why this would be so. It simply appears, either by choice or by direction, that whilst men were happy to be photographed with dogs and other animals, the majority of male stars were not happily coupled with cats.

Whilst the overwhelming focus of *Hollywood Cats* is on the type of creature that we might be happy to let lounge around our homes and clear our yards of mice, it is impossible not to mention the role that their larger relatives played in the history of Hollywood. Lions, tigers, leopards, cheetahs, and jaguars were attractive to filmmakers as a practical means of creating a very real spectacle.

Lions had become so popular in slapstick comedies that by the mid-1920s specialised farms sprung up in neighbourhoods close to the studios. The most famous of these were Goebel's Lion Farm and Gay's Lion Farm, the latter of which had over 200 lions on it premises at the height of the mania for these animals. Besides grasping every possible photo opportunity with these 'wild' animals, every star of the era was cast alongside a lion or a tiger at some point. Indeed, they had become so prevalent that they were subject of a 1923 Hollywood spoof entitled *The Extra Girl* – the story of an aspiring actress, played by Mabel Normand, who encountered unimaginable numbers of the animals when hanging around a movie set.

The attraction of these big cats faded with time and by the 1940s most of the farms were closed. Animal rights activists played a part, but largely it was down to the simple fact that there were only so many films that could be made with these supposedly wild animals – the audiences craved something more sophisticated than yet another lion tale.

The first true feline star of the screen simply disappeared one day following the death of her greatest friend, Teddy the dog. Mack Sennett issued a press release expressing his gratitude to his friend Pepper and added in true Hollywood style 'at least she retired at the top'. Despite her passing, and that of every other cat in the following pages, one constant remained – in whatever capacity, cats continued to play an important role in the life of Hollywood. There is a saying that you never really own a cat, rather the cat owns you. If that really is the case then we should be grateful that they allowed themselves to be photographed at all, for they are just as much the stars of the show as their generally better known human counterparts.

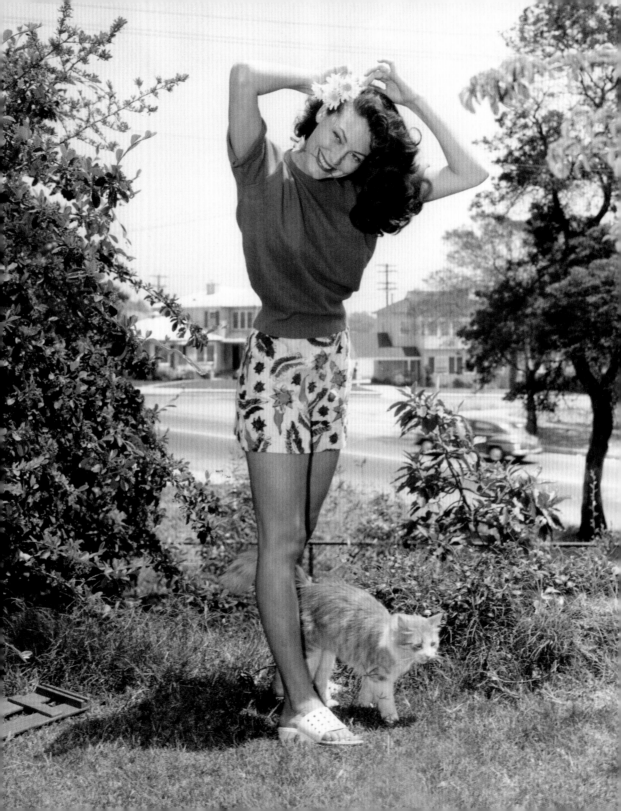

Ava Gardner, MGM, 1949

Pinning flowers in her hair, Gardner relaxes
with a stray cat in the Californian sunshine
Photograph by Nat Dallinger

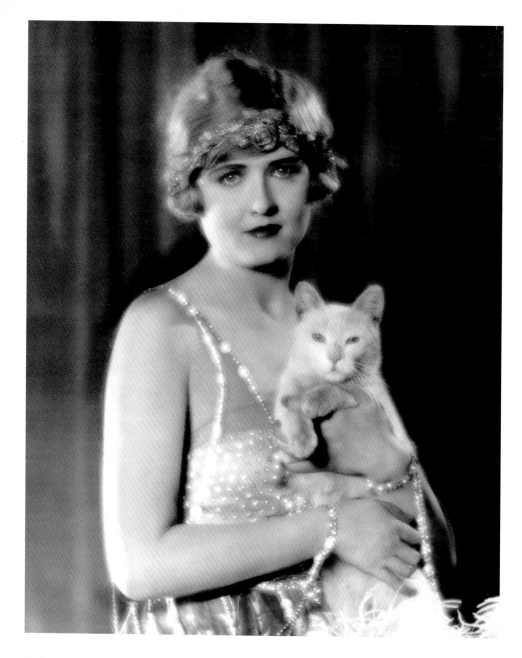

Harriet Hammond, Mack Sennett
Comedies, 1921

The jewelled star of the silent screen
pictured with her cat
Photograph by Harold Dean Carsey

Phyllis Haver, Mack Sennett Comedies, 1921

By the time she retired from acting in 1929,
and after just fifteen years in Hollywood,
Haver had over one hundred credits to her
name, reinforcing her reputation as one of
the silent screen's busiest actors
Photograph by Kenneth Alexander

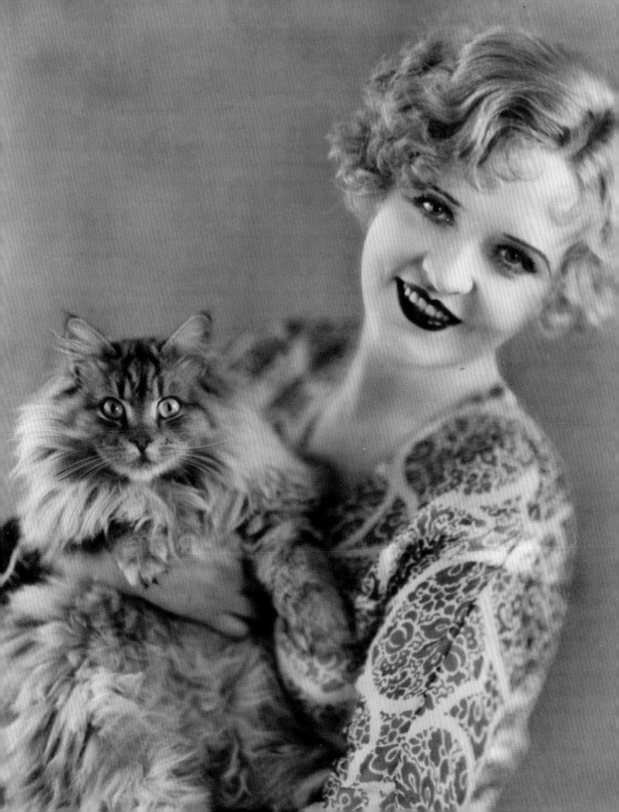

Jean Harlow, MGM, 1932

An avid animal enthusiast, Harlow poses at home
with her Black Persian named His Royal Highness.
Harlow also kept two alley cats she found – she
christened them simply Good Cat and Bad Cat

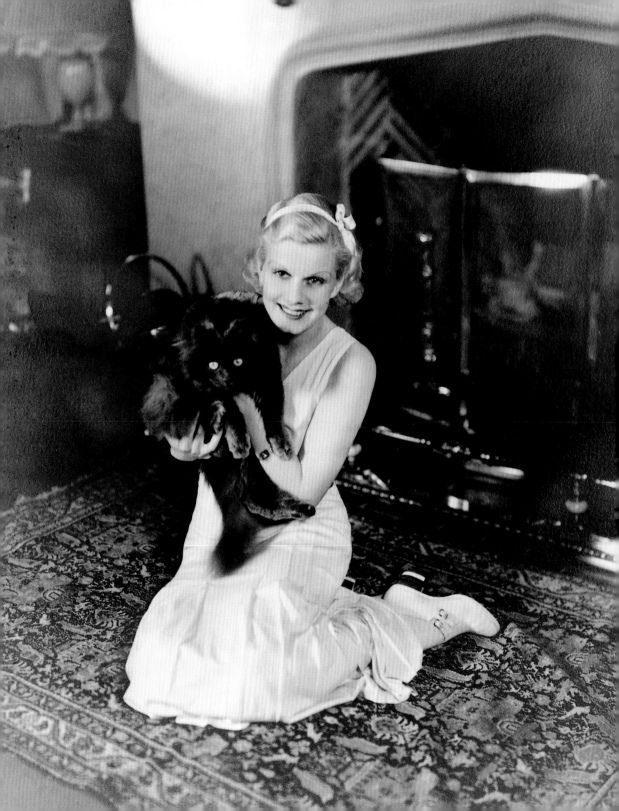

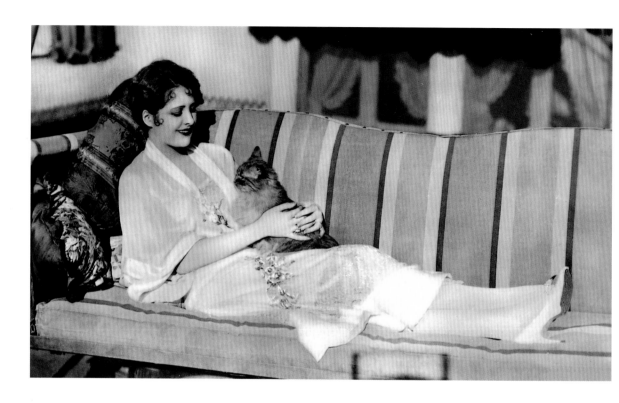

Billie Dove, Paramount Pictures, 1925

A star to rival all the great names of the silent era, Billie Dove retired in 1932, just a few years after the talkies became so popular. Rumour has it that she was left dismayed by the role William Randolph Hearst played in her character being savagely cut from the film *Blondie of the Follies* – apparently Dove had outshone top-billing star of the show and Hearst's lover Marion Davies

Heather Angel, Fox Film Corporation, 1934

The British actress was in great demand following her move to Hollywood and is best remembered for her role in the *Bulldog Drummond* series of films. This photograph is from a series of images of famous Hollywood actresses with their pets that was made available to the public as postcards in the early 1930s.

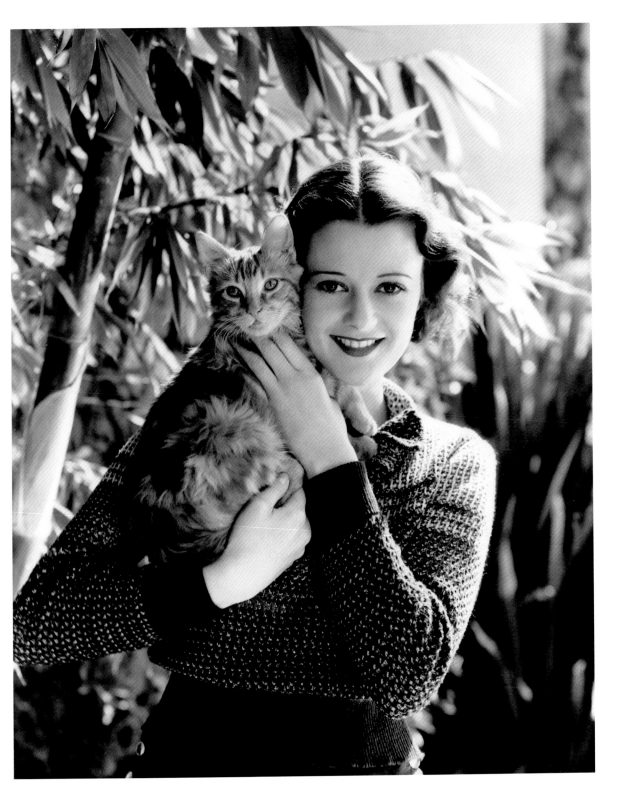

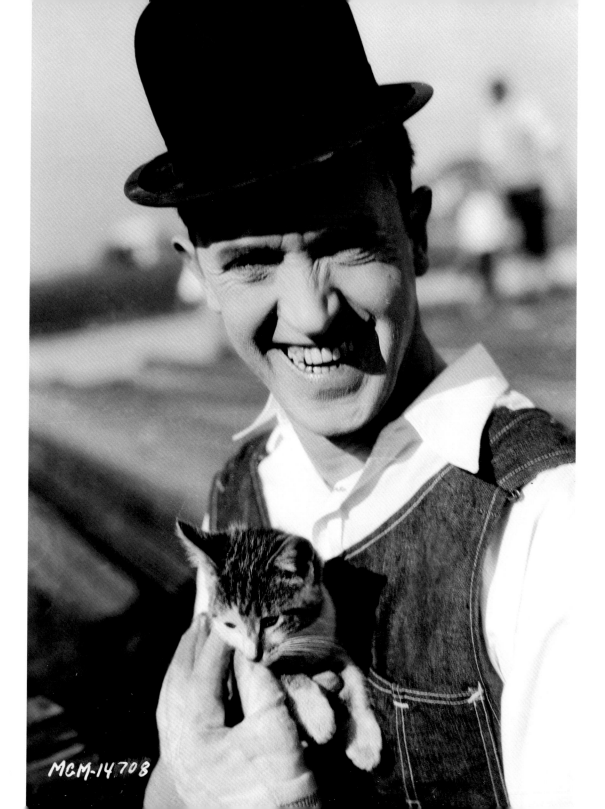

MGM-14708

Stan Laurel, MGM/Hal Roach Studios, 1927

The British actor cradles a kitten during the filming of the silent comedy *The Finishing Touch*

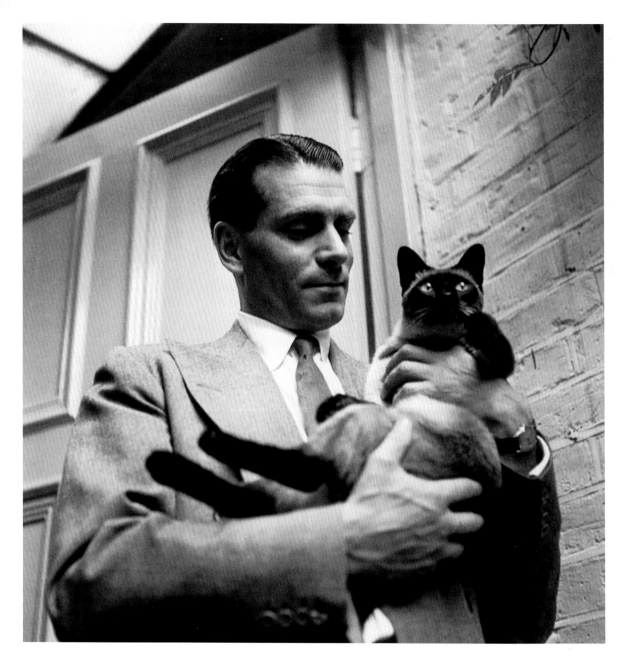

Laurence Olivier, 1946

At home in London with New Boy, one of Vivien Leigh's many Sealpoint Siamese cats. New, as he was known, was a constant travelling companion of Leigh's and was named after London's New Theatre. Olivier knew how much her cats meant to Leigh and often bought gifts for them, including an ornamental collar with gilt bells for New

Vivien Leigh, 1946

Leigh with her beloved New Boy. She was devoted to cats and her daughter recalls that there were no less than sixteen living with the actress at one point. The Siamese was her favourite breed. 'Once you have kept a Siamese you would never have any other kind. They make wonderful pets and are so intelligent they follow you around like little dogs', Leigh commented in 1948 while in New Zealand with her husband

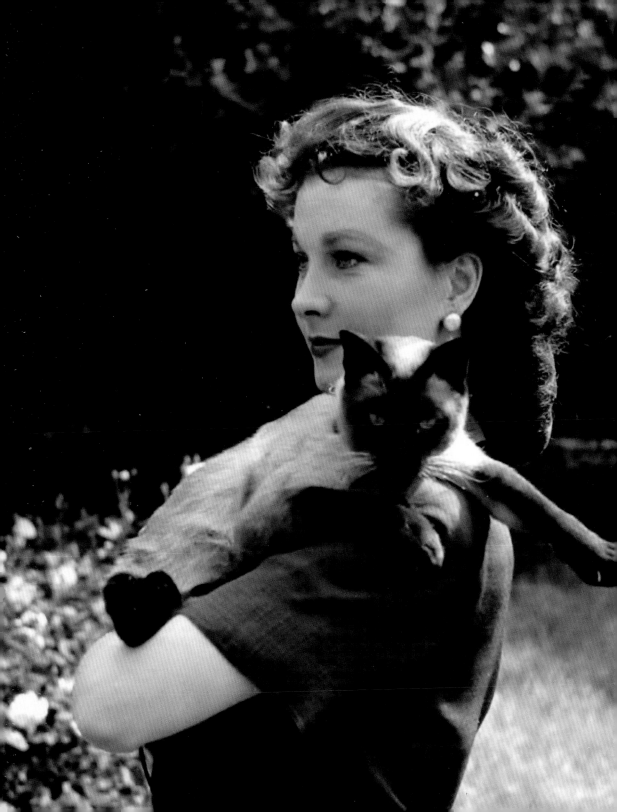

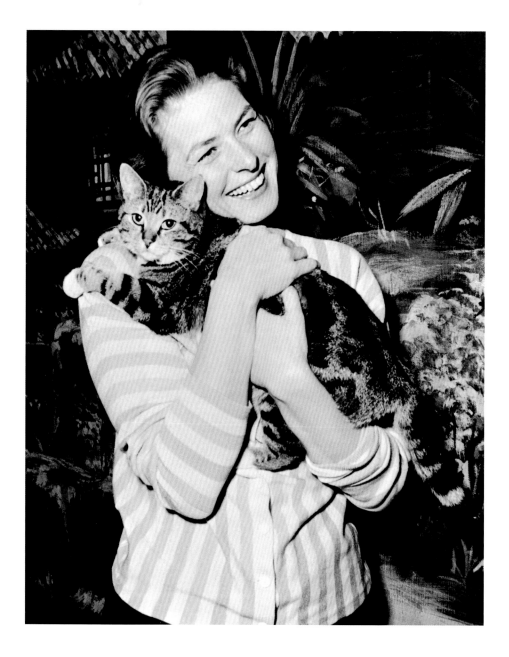

Ingrid Bergman, c. 1958

After starring in *Casablanca* in 1942, Bergman became one of Hollywood's top box-office draws. Despite a seven-year exile from Hollywood during the early and mid-1950s, she was still able to return and maintain her status as a major star in films such as *Indiscreet* and *The Inn of the Sixth Happiness*

Jane Russell, RKO Radio Pictures, 1951

Posing with her white angora cat on the set of *His Kind of Woman*

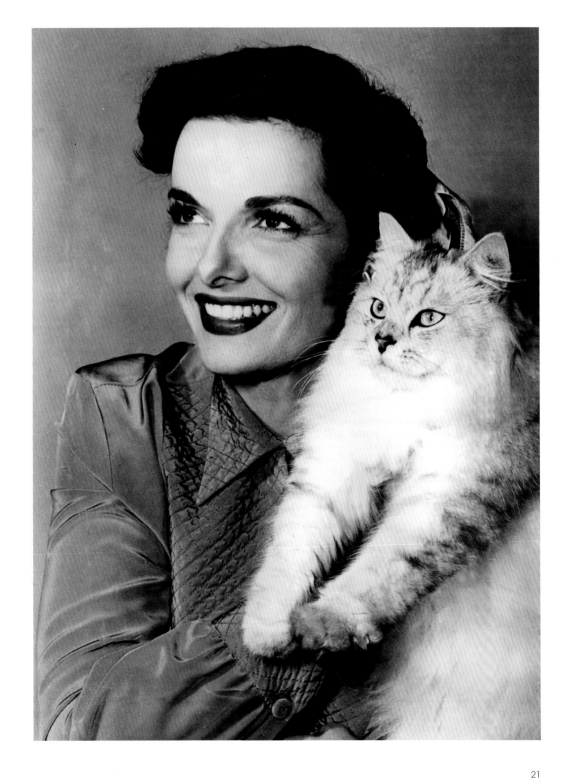

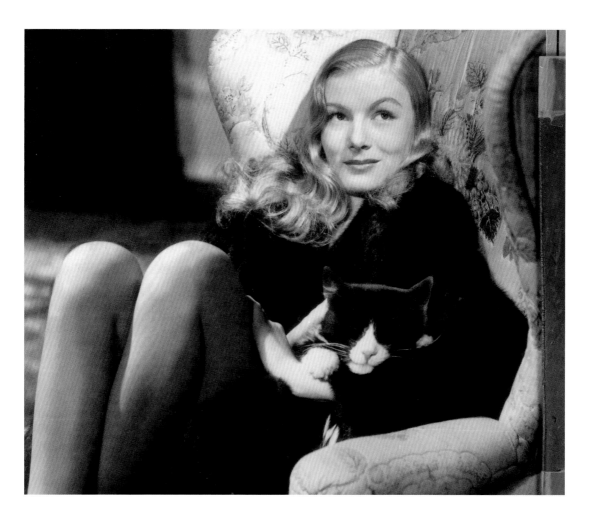

Veronica Lake, Paramount Pictures/United Artists, 1942

Photographed on the set of *I Married a Witch*, Lake is seated with a sizable cat who fell asleep during shooting. The production was beset with problems due to Lake's alleged unprofessional behaviour, and she was subsequently regarded in low esteem by her co-stars, including Frederic March who nicknamed the film 'I Married a Bitch' in a direct reference to Lake

Suzan Ball, Universal Pictures, 1952

An early publicity shot with a Siamese cat to announce her first credited role in *Untamed Frontier*. Ball was discovered after scouts saw a newspaper picture of her receiving first prize in a baking contest. Soon Hollywood cameramen were calling her 'The Girl With Five Faces' as they said she bore a striking resemblance to no less than five stars – Jane Russell, Lana Turner, Linda Darnell, Elizabeth Taylor and Ava Gardner

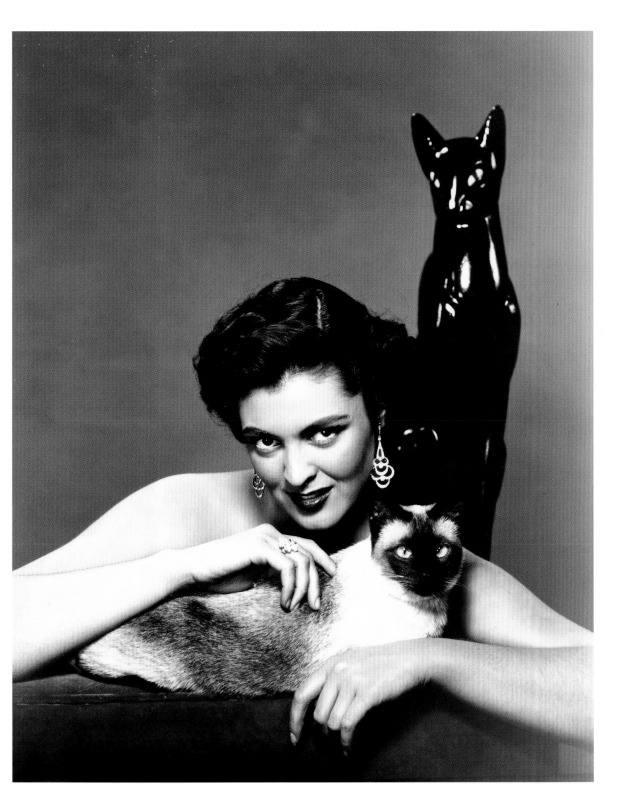

Elizabeth Taylor, MGM, c.1950

A publicity shot taken in her Hollywood garden

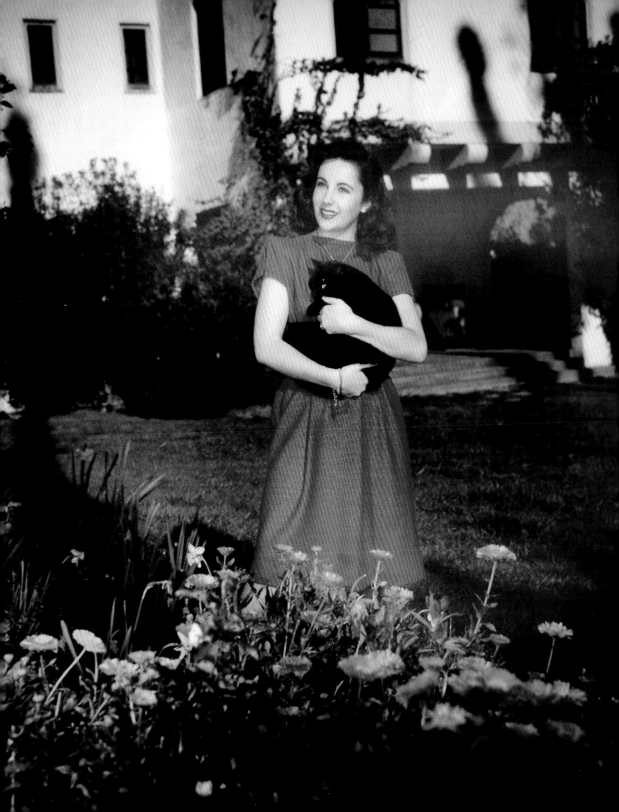

Marlene Dietrich and Victor McLaglen,
Paramount Pictures, 1931

Dietrich stars as Maria, an Austrian
prostitute seduced into spying on the
Russians – an activity that ultimately
leads to her death by firing squad in
Dishonored. Known simply as X27,
Dietrich's character is devoted to the
black cat that is ever-present and
accompanies her on missions. The
director of the film, Josef Von Sternberg,
was not initially keen on the cat
appearing, but conceded when the star
insisted that 'cats always bring me luck'

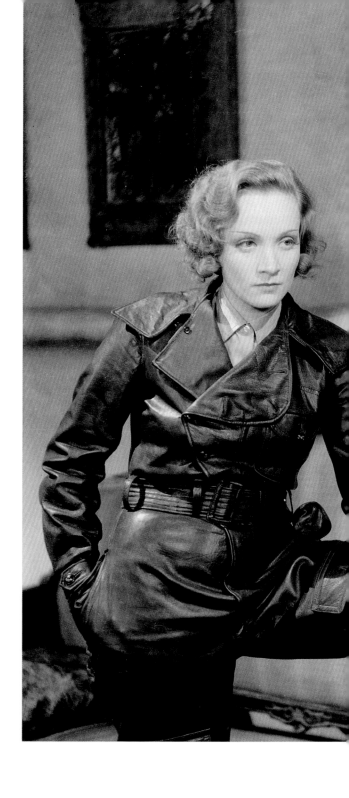

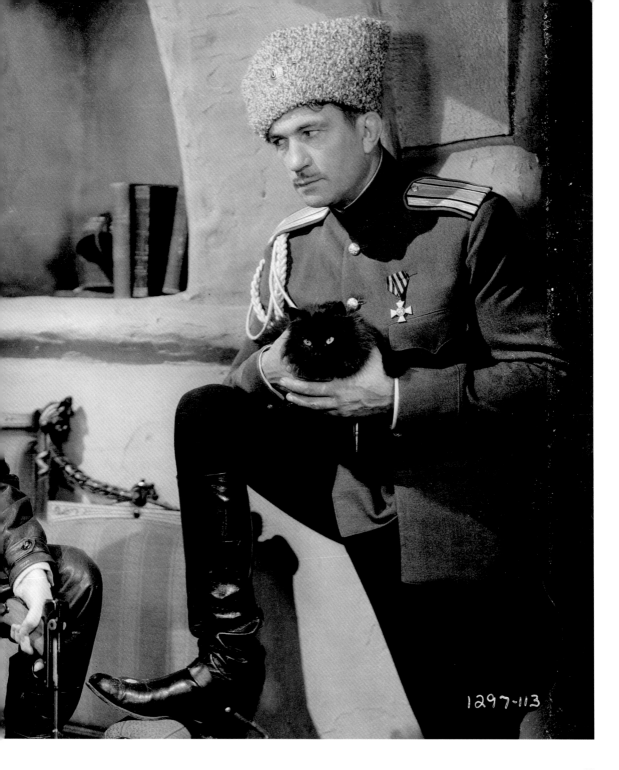

1297-113

Jean Simmons, Wessex Film Productions, 1947

In between takes of *The Woman In the Hall*, Simmons would often wander over to the local farm near Pinewood Studios and make friends with all of the animals. Here one of the farm kittens is on the receiving end of her affection

Norma Shearer, MGM, c.1938

Labelled as 'The First Lady of MGM', Shearer won an Oscar in 1930 for her role in *The Divorcee* (she was nominated a further five times). Shearer attempted to retire in 1936, following the death of her husband, but was persuaded by the studio to sign a new six-picture contract. Despite this, she manages to look extremely content in this studio publicity shot

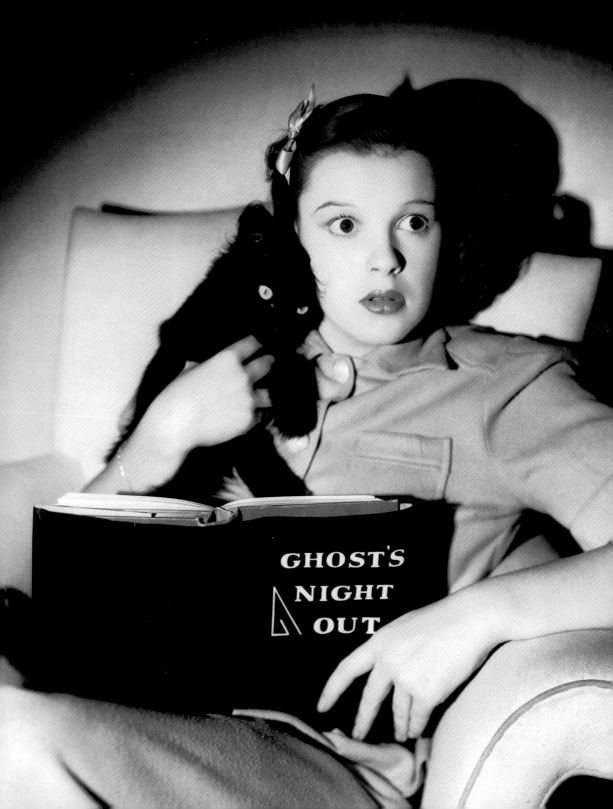

Judy Garland, MGM, 1938

All studios shot promotional material to celebrate
occasions such as Halloween. A wide-eyed Garland is
seen here a year before the release of *The Wizard of Oz*
Photograph by Eric Carpenter

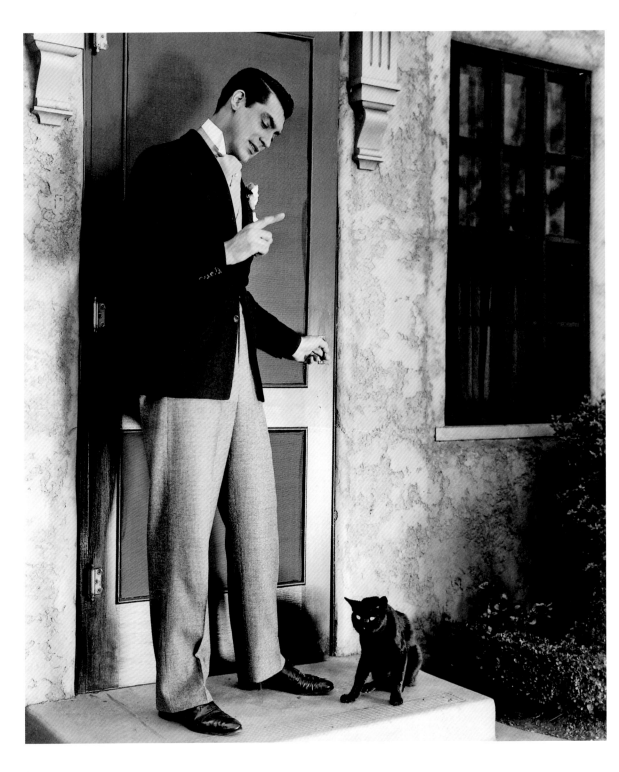

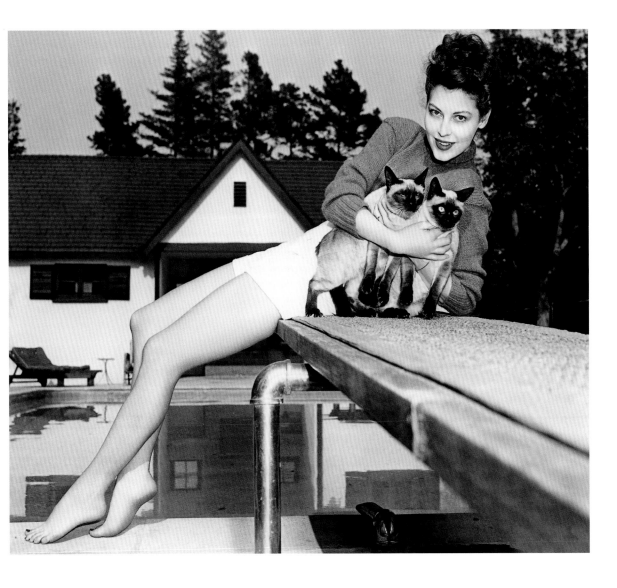

Cary Grant, Paramount Pictures, 1934

Between takes, Grant offers some words
of advice to a black cat on the set of
Kiss and Make-Up

Ava Gardner, Universal Pictures, 1946

Between marriages to Mickey Rooney and
Frank Sinatra, Gardner was also briefly
married to the band leader and musician
Artie Shaw. She is photographed here in 1946
with Shaw's two Siamese cats

Loretta Young, First National Pictures, 1930

Young appeared in her first movie as a one-year-old child. It was the beginning of a journey that would culminate in an Oscar-winning performance in the 1947 film *The Farmer's Daughter*

Sabu, Universal Pictures, 1946

The star of *The Jungle Book* poses happily
with a leopard cub whilst on a visit to Miami

Buster Crabbe, Sol Lesser Productions, 1933

Crabbe stars as the fabled man raised by
apes in *Tarzan the Fearless*

Josephine Baker and Chiquita, c.1931

Baker rose to fame in France during the 1920s as a cabaret
star. It was during her time spent in Paris that Baker was gifted
a cheetah which she named Chiquita – she was often seen
wandering the streets of the capital with the pet wearing a
diamond-studded lead and collar. Besides being a prominent
civil rights activist, Baker adopted no fewer than twelve
children, as well as assembling a menagerie of pets – including
pigs, cats, dogs, parrots, rabbits, a goat and a calf – many of
which took up residence in her dressing room when she
performed

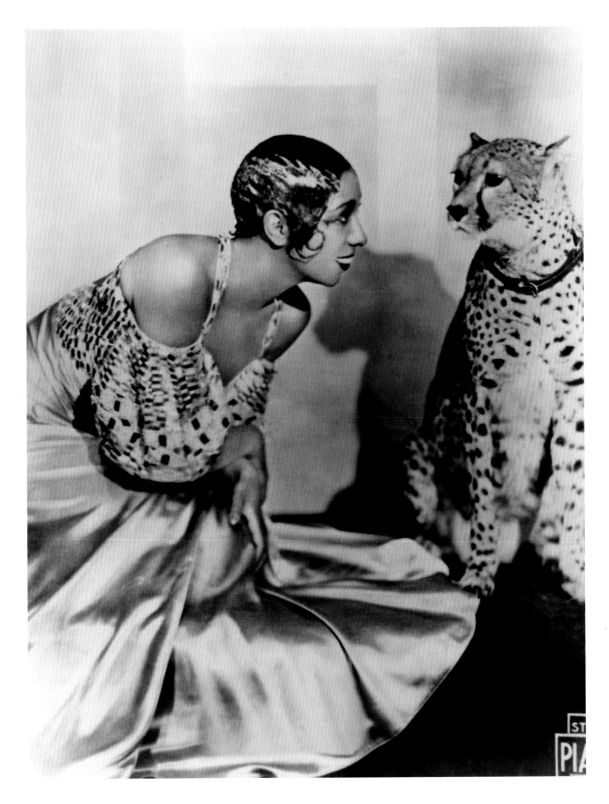

ST
PIA

Ann Sheridan, Warner Brothers, 1942

Given the success of many of her films and in protest over the salary of $600 a week Warner Bros paid her, Sheridan had gone on a six-month strike the year before this studio portrait was shot. She wanted more but was back to work within six months as the studio held their nerve

Anita Ekberg, Riama Films, 1960

In Federico Fellini's *La Dolce Vita*, Swedish actress Anita Ekberg cradles a tiny kitten in her hands. It is the scene in which she gets soaked in the Trevi Fountain, however, for which she is most famously remembered

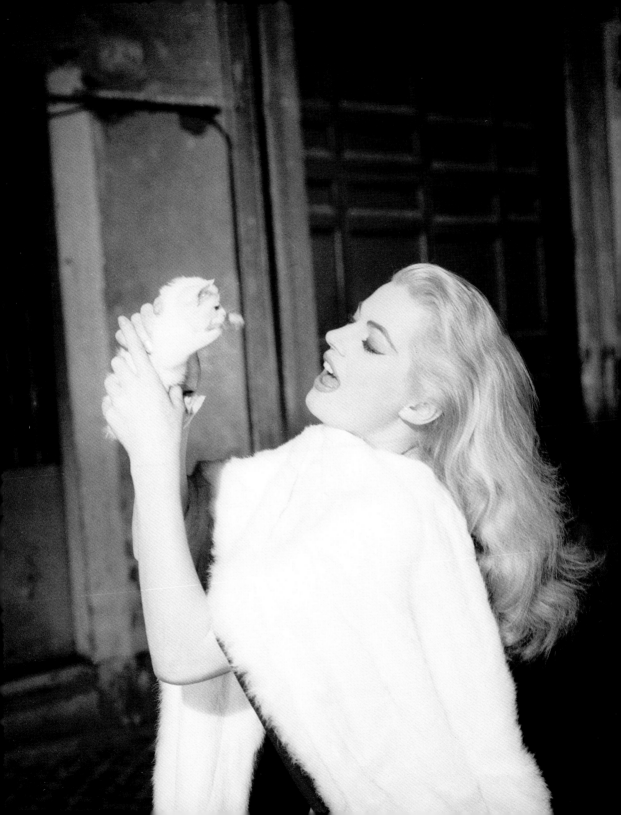

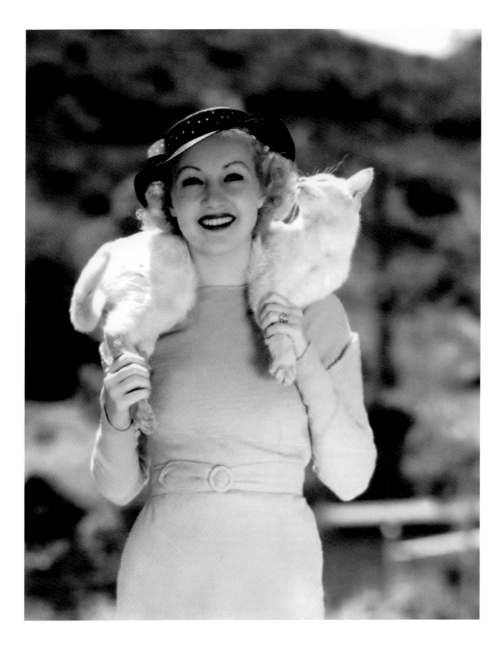

Betty Grable, RKO Radio pictures, 1935

Wearing Whitey like a scarf, Grable poses for an early
publicity shot. Earning $125 per week, Whitey was under
contract to RKO. His trainer, Henry East, recalled that it
took about two months for the cat to learn each new
trick he was required to perform. He had three very
distinct meows that he could perform on command and
was so valuable to the studio that there was a stand-in
cat available at all times when he was on set

Mary Pickford, Mary Pickford Company, 1916

A familiar and conventionally honeyed
image of Pickford with a kitten on her
shoulder. In reality she was an extremely
shrewd businesswoman who made barely
imaginable sums of money from both on-
and off-screen activities

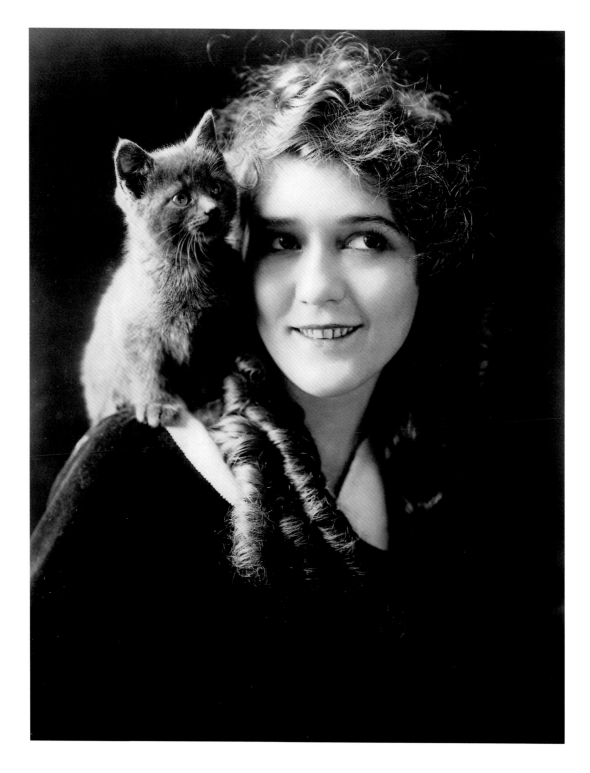

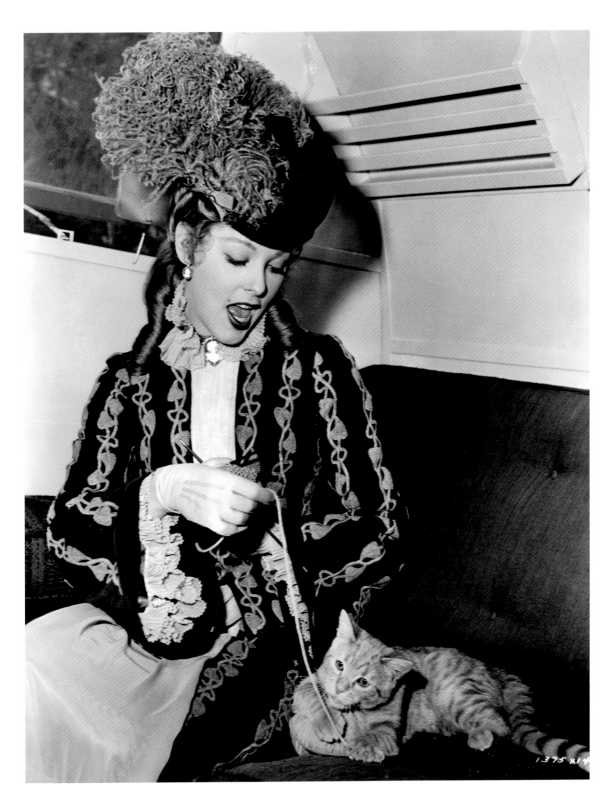

1375 X14

Arlene Dahl, MGM, 1951

Taking time out in her dressing room on the set of
Inside Straight, Arlene Dahl finds time to play with this
small feline visitor – one of the many cats who made
their homes on the studio lots with no fear of eviction

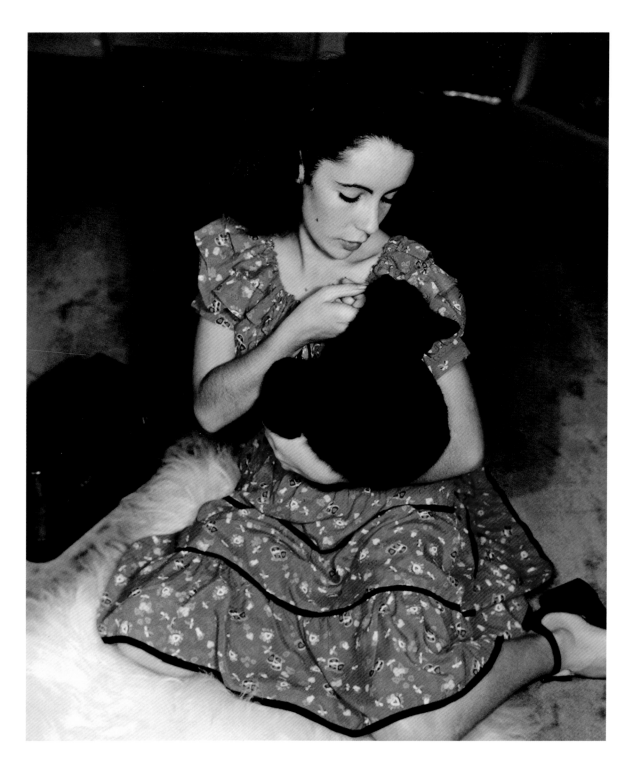

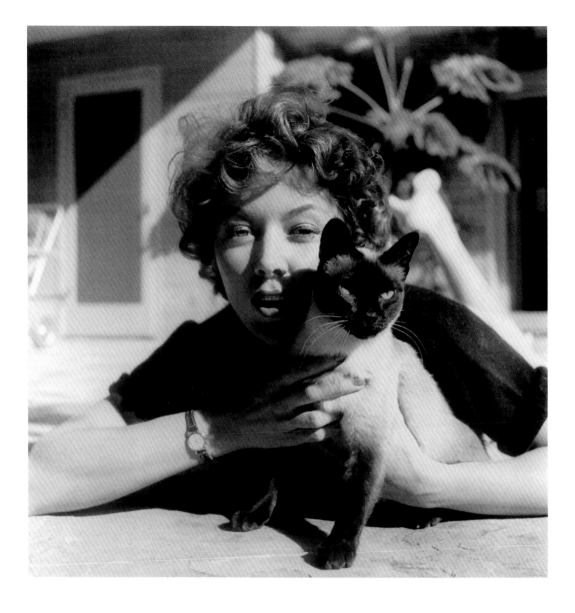

Elizabeth Taylor, MGM, 1946

A fourteen-year-old Taylor affectionately strokes her cat under the chin. Taylor was already a huge star by this time, having starred opposite Mickey Rooney in the phenomenally successful *National Velvet*

Gloria Grahame, c.1955

Photographed with her pet Siamese at her San Fernando home. Despite receiving acclaimed reviews for films such as *It's a Wonderful Life* and *Oklahoma*, as well as an Oscar-winning performance in *The Bad and the Beautiful*, Grahame's career was somewhat unsettled. Frequently moving between studios, she brought with her a reputation for being less than straightforward

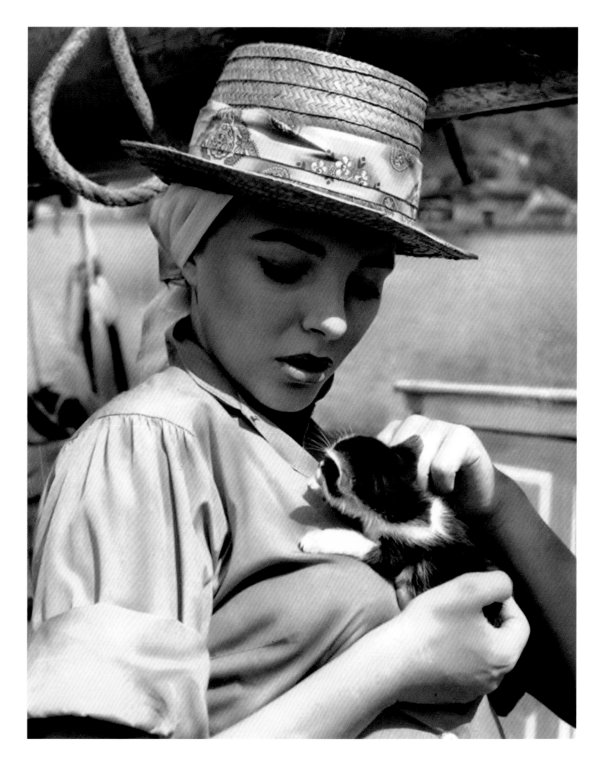

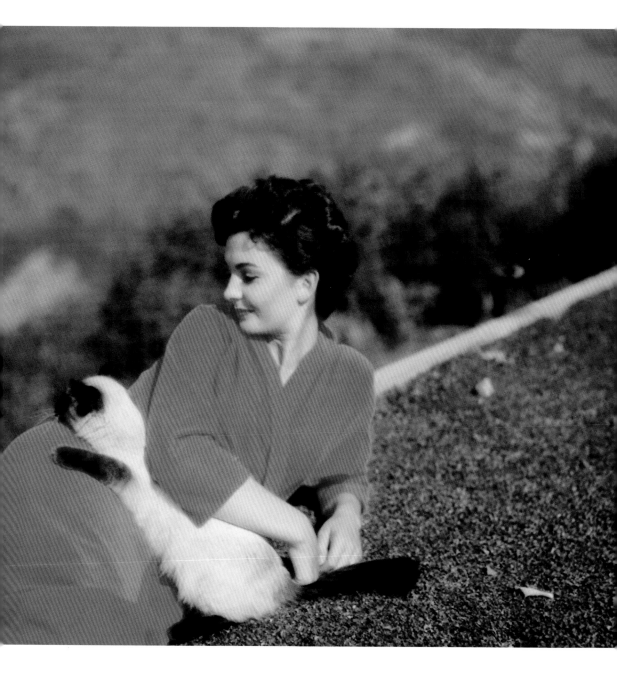

Joan Collins, 20th Century Fox, 1957

Protecting herself from the sun, Collins
plays with a kitten during the filming of
Island In the Sun on location in Barbados

Jean Simmons, 20th Century Fox, 1954

The British actress relaxes with her Siamese in the year she
starred opposite some of Hollywood's greatest leading men,
including Marlon Brando, Robert Mitchum and Peter Ustinov
Photograph by Baron

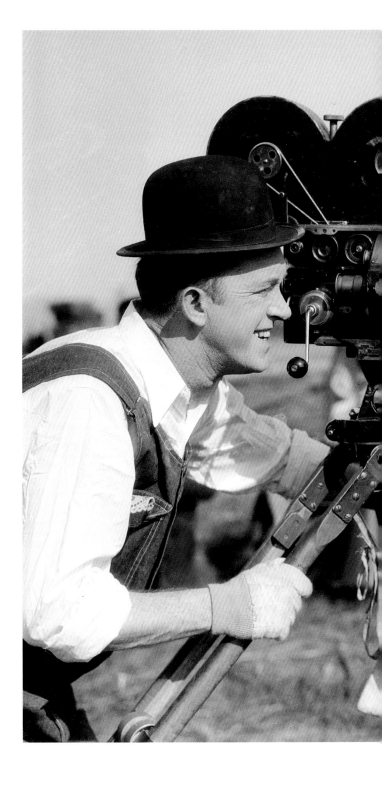

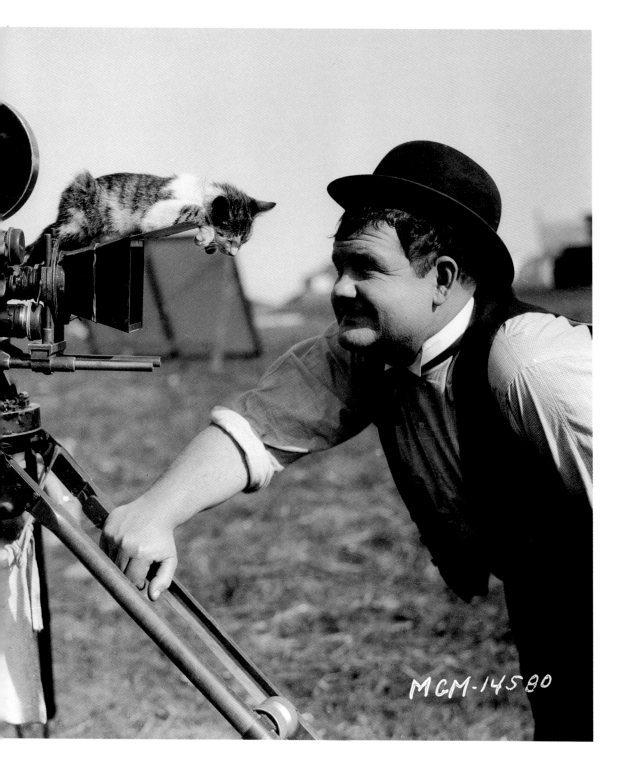

MCM-14580

51

Sylvia Sidney, Paramount Pictures, 1932

Still in full costume, Sidney relaxes with a Siamese cat during a
break in filming. The star plays the tragic figure of the geisha
Cho-Cho San in the cinematic version of *Madame Butterfly*.
The reviews for the film were not particularly flattering despite
a cast that also featured Cary Grant in a starring role

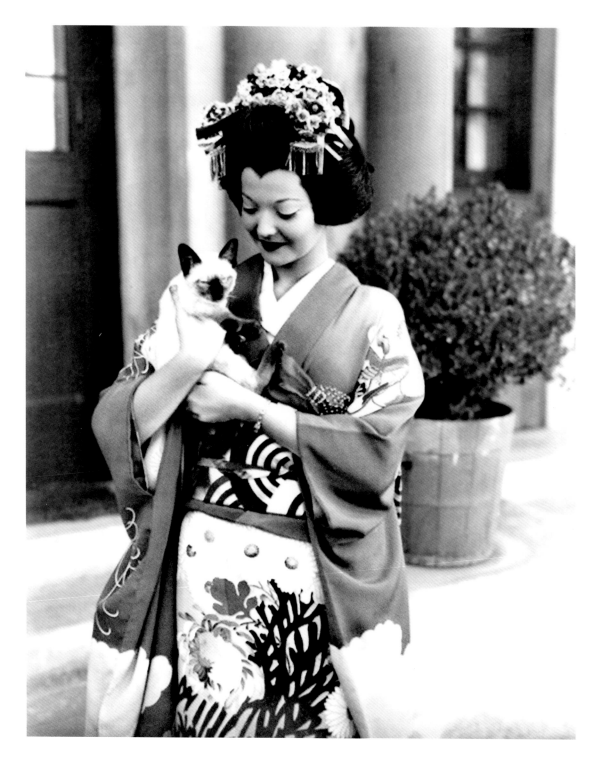

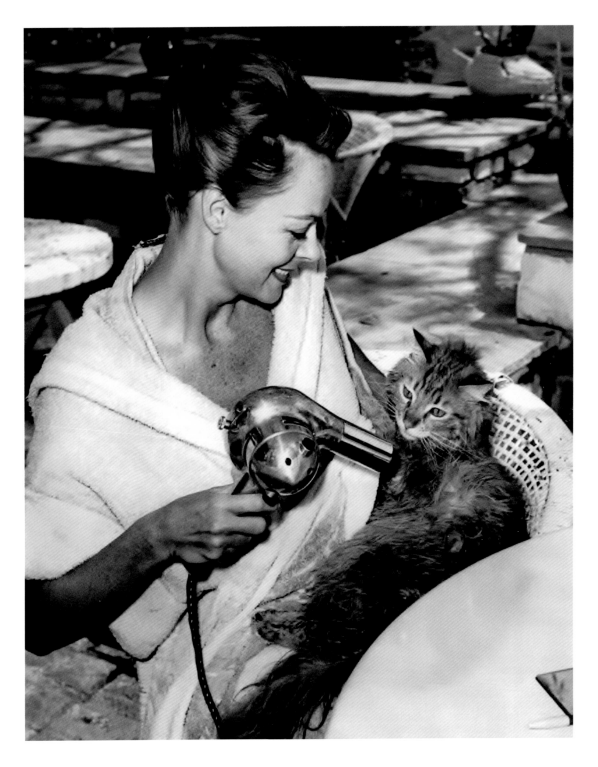

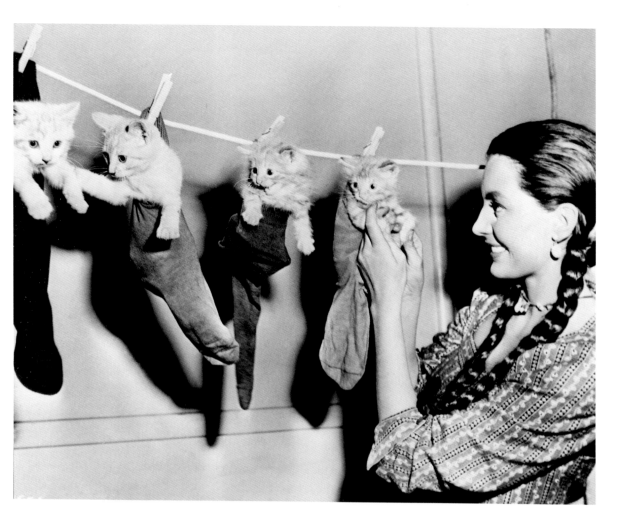

June Lockhart, 1960

George the cat took a daily dip in Lockhart's
Hollywood swimming pool. He was one of five
cats owned by the star of *Lassie* and is seen
here being blow-dried after one of his swims

Cyd Charisse, MGM, 1952

Looking more than a little concerned, four kittens hang precariously
from a washing line on the set of *The Wild North*. The film was released
in the United States in the same week as *Singing In The Rain*, in which
Charisse played a leading role opposite Gene Kelly – it was the role
that made her a star

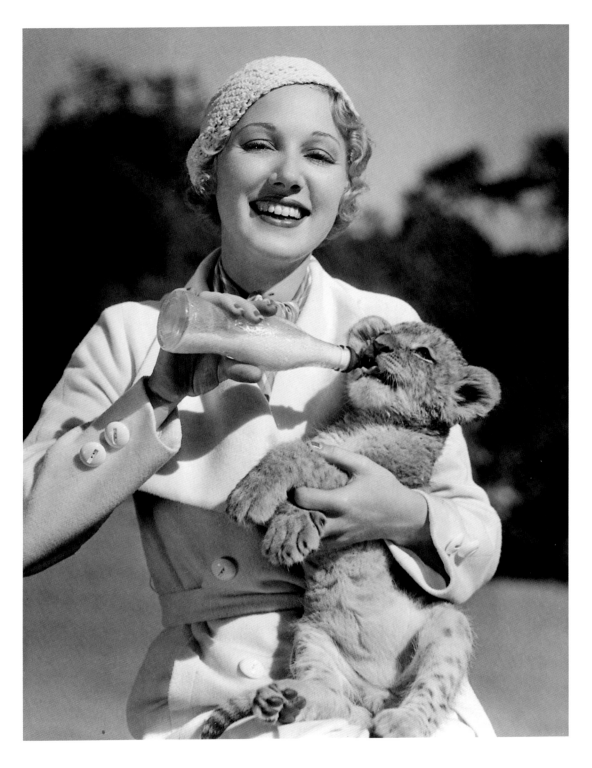

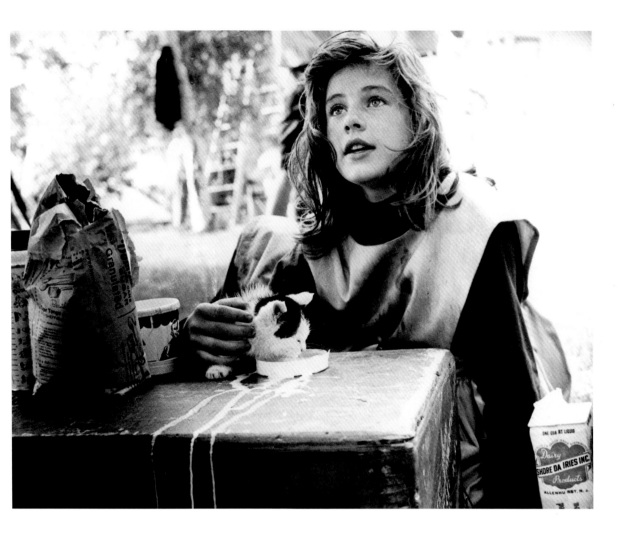

Leila Hyams, MGM, 1932

On a visit to the Goebel Lion Farm in Los
Angeles, Hyams feeds a lion cub called
Metro who was a descendent of Leo,
the original MGM trademark lion (his two
brothers were somewhat predictably
christened Goldwyn and Mayer)

Patty Duke, Playfilm Productions/United Artists, 1962

Duke plays the frustrated and violent Helen Keller in *The Miracle Worker*, the
story of a blind, deaf and mute girl's struggle to communicate with the world.
It was on the Californian ranch where the film was shot that Duke came
across this tiny kitten, who seems only too pleased to accept a makeshift
saucer of milk. Duke won an Academy Award for the role and for many years
the sixteen-year-old was the youngest person ever to win an Oscar

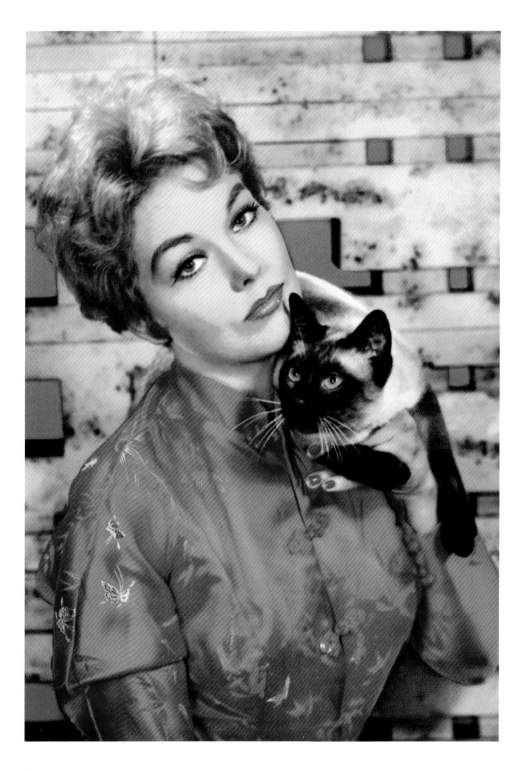

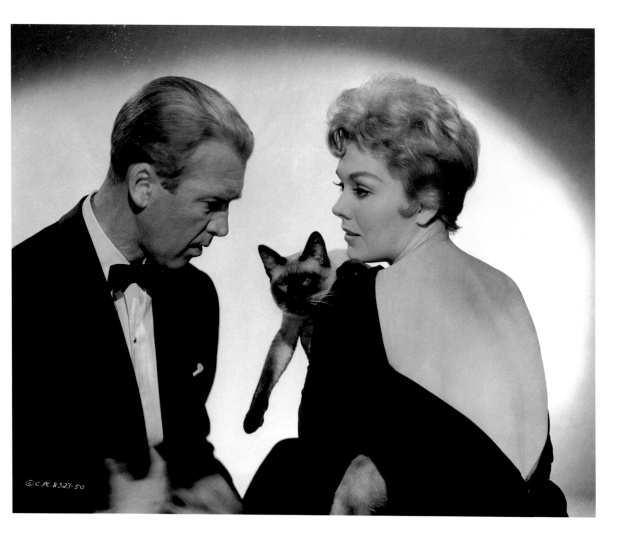

©C.PC 8323-50

Kim Novak, Columbia Pictures, 1958

Novak loved Siamese cats so much that
she owned nine of them. She is most
famously associated with a witch's cat
called Pyewacket in the film *Bell Book and
Candle*

James Stewart and Kim Novak, Columbia pictures, 1958

With a natural flair for witchcraft (and having grown bored with the
company of fellow sorcerers), Gillian Holroyd and her Siamese cat
Pyewacket cast a spell over her handsome neighbour, played by
Stewart, in *Bell Book and Candle*. Pyewacket won a PATSY Award
(Picture Animal Top Star of the Year award) in 1959 for his role in the film

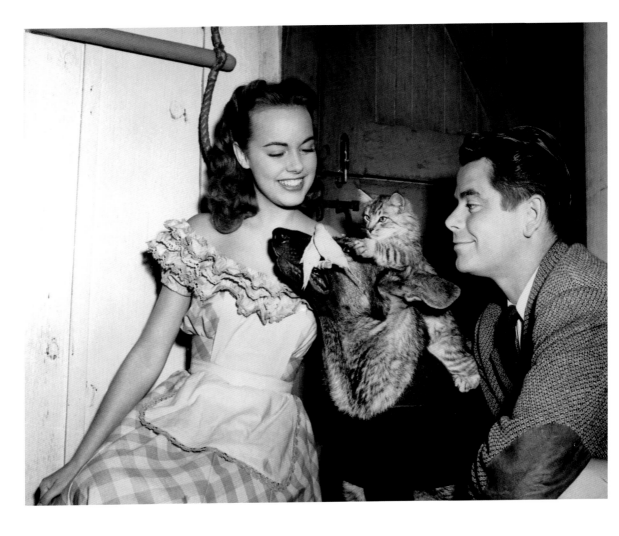

Terry Moore and Glenn Ford, Columbia Pictures, 1948

On the set of *The Return of October*, Moore and Ford
look on in amusement as their pets, somewhat
surprisingly, get along with each other

Jean Parker, MGM, 1935

The American actress holds a kitten
aloft in an MGM studio portrait

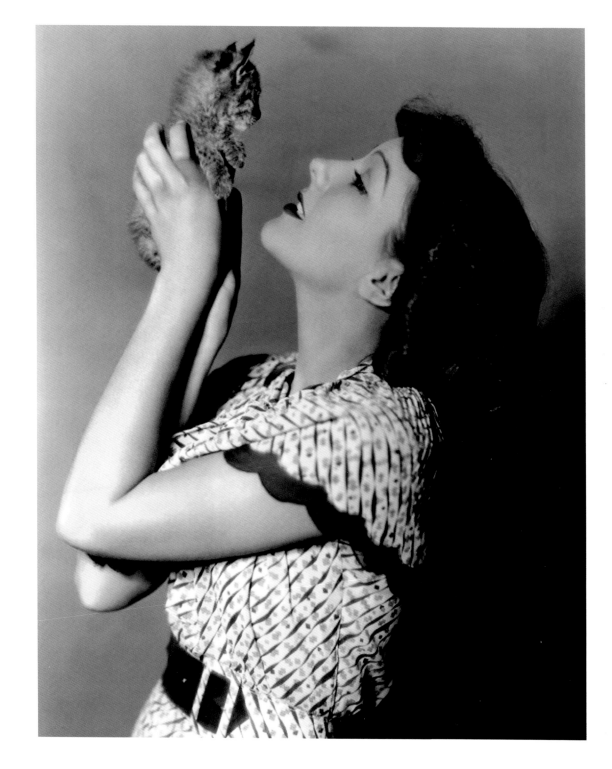

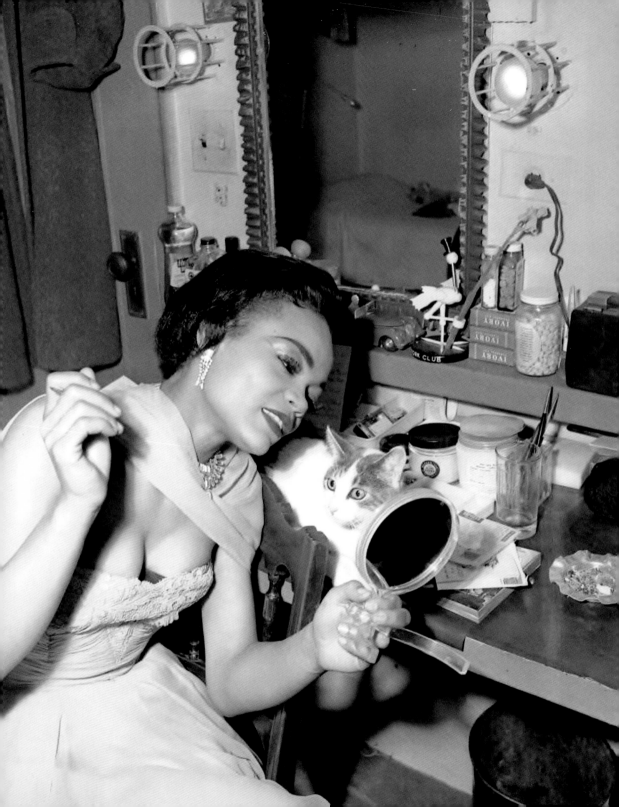

Eartha Kitt, 1953

Some fourteen years before she would
famously star as Catwoman, Kitt checks her
make-up with her cat Jinx, who was well
known for liking the comfort of her mistress's
dressing room

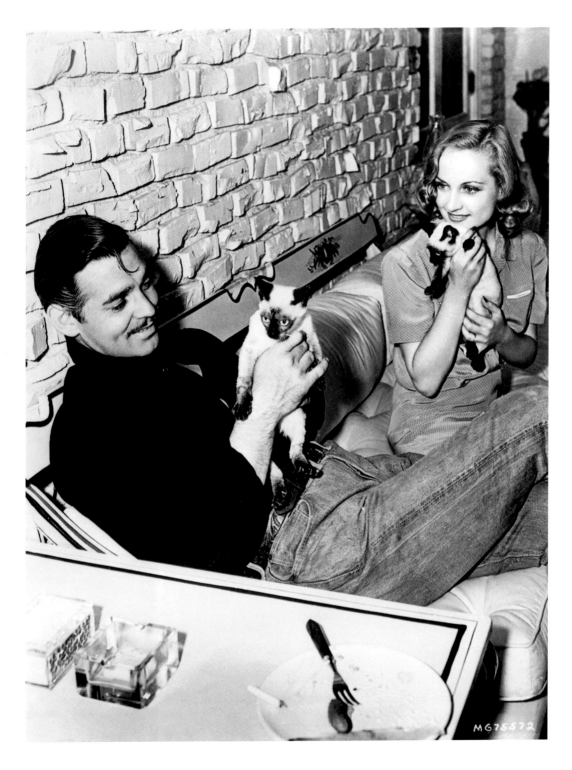

MG75572

64

Clark Gable and Carole Lombard, 1940

This relaxed portrait of Gable and Lombard was taken at their
home in the San Fernando Valley soon after they married. Other
than these Siamese siblings, the couple kept dogs and various
farmyard animals. A few years later Lombard was to die in a
plane crash in Nevada

Grace Kelly, 1948

Aged nineteen and several years before
moving to Hollywood, Kelly worked as a
part-time model in New York advertising,
among other things, Old Gold Cigarettes

Carole Lombard, Paramount Pictures, c.1932

Seen here posing with a black cat in a studio
publicity shot
Photograph by Eugene Robert Richee

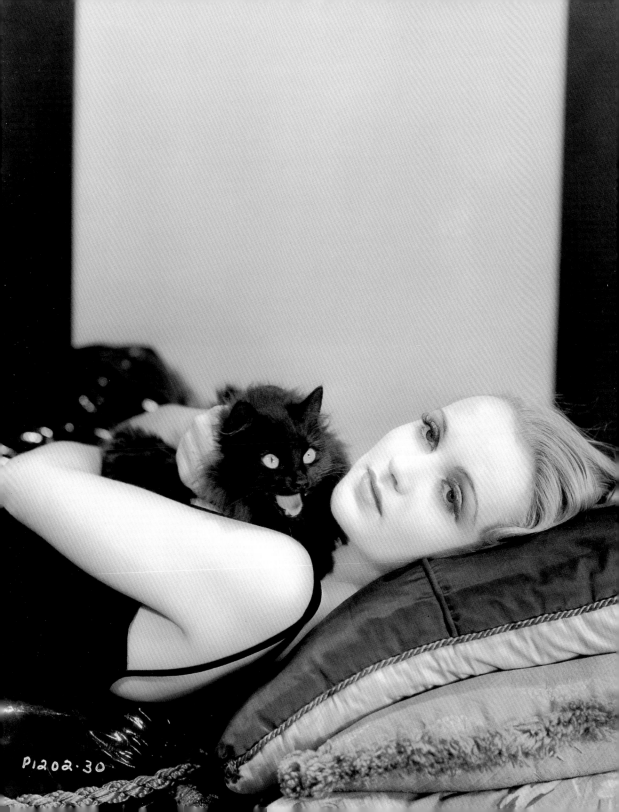

P1202·30

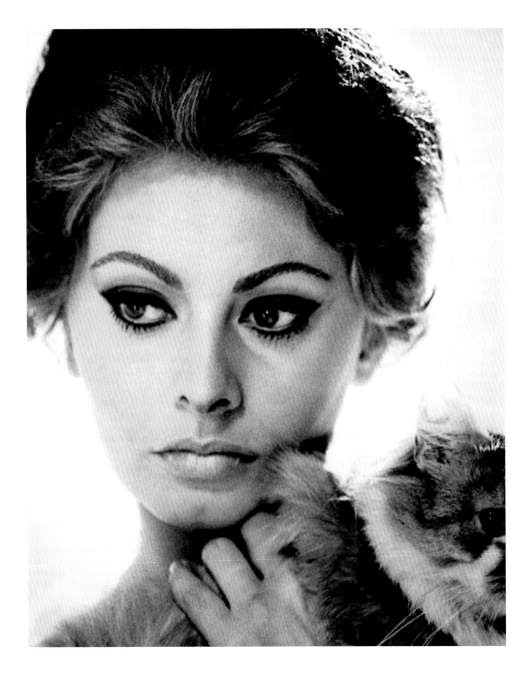

Ursula Andress, Eon Productions, 1962

Photographed with an Oriental
Shorthair in the year that the Swiss
actress famously starred as Honey
Ryder opposite Sean Connery's James
Bond in *Dr No*.

Sophia Loren, c.1961

With a string of credits already to her name,
the Italian actress arrived in Hollywood in
1957 and was cast in roles opposite the likes
of Cary Grant, Marlon Brando, Gregory
Peck, Paul Newman and Charlton Heston

Mia Farrow, 1965

Photographed with her cat Malcolm who,
besides being deaf, shunned cat food in
favour of jars of baby food

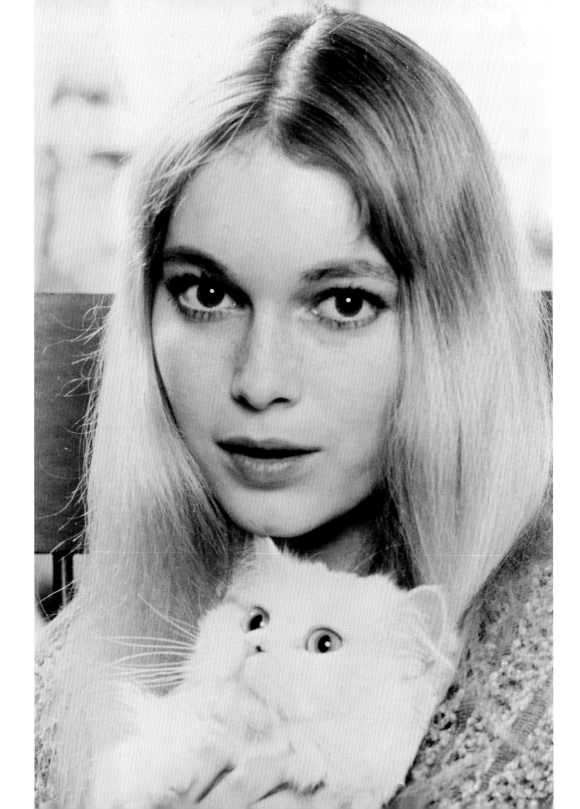

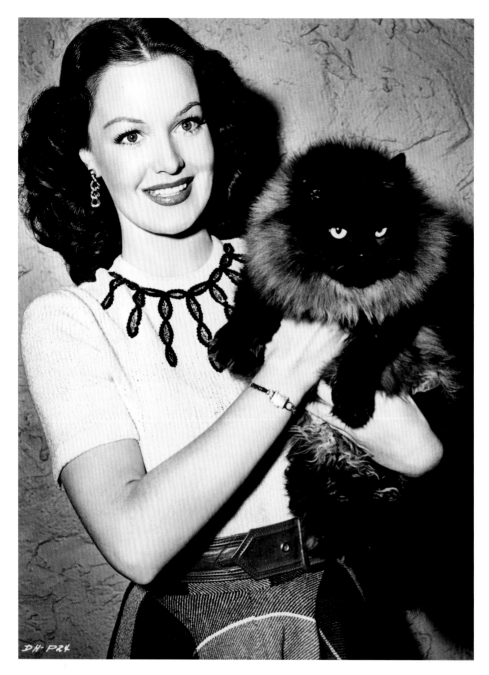

Dorothy Hart, Universal Pictures, 1948

A studio publicity shot taken in the year she starred in the award-winning film *The Naked City*. Having grown to dislike Hollywood so much, Hart brought her film career to a premature end in 1952. It was less than five years since her debut in Columbia's *Gunfighters* with Randolph Scott

Elizabeth Taylor, MGM, 1953

Finding time to play with a kitten in her dressing room between takes of *The Girl Who Had Everything*

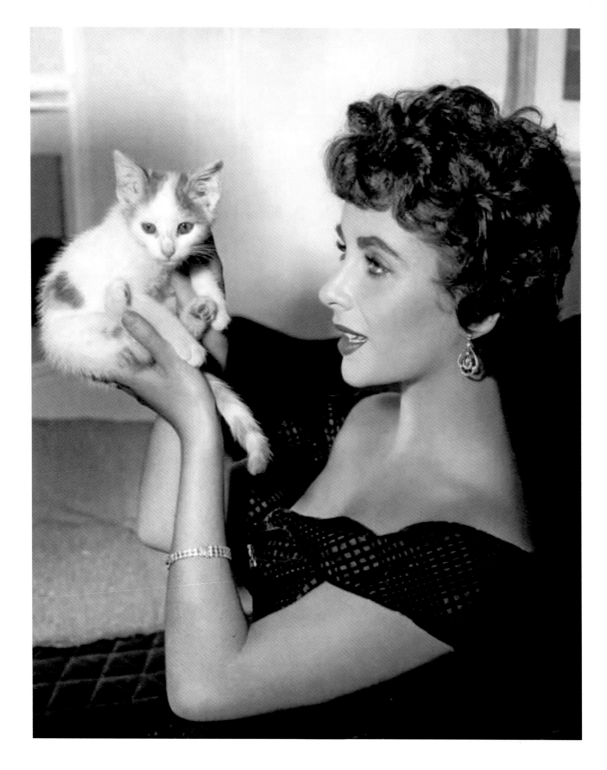

Elizabeth Taylor, MGM, 1953

A tiny kitten hitches a ride in Taylor's pocket on
the set of *The Girl Who Had Everything*. Despite
Taylor being one of Hollywood's brightest stars
this was the only film featuring her that MGM
released this year

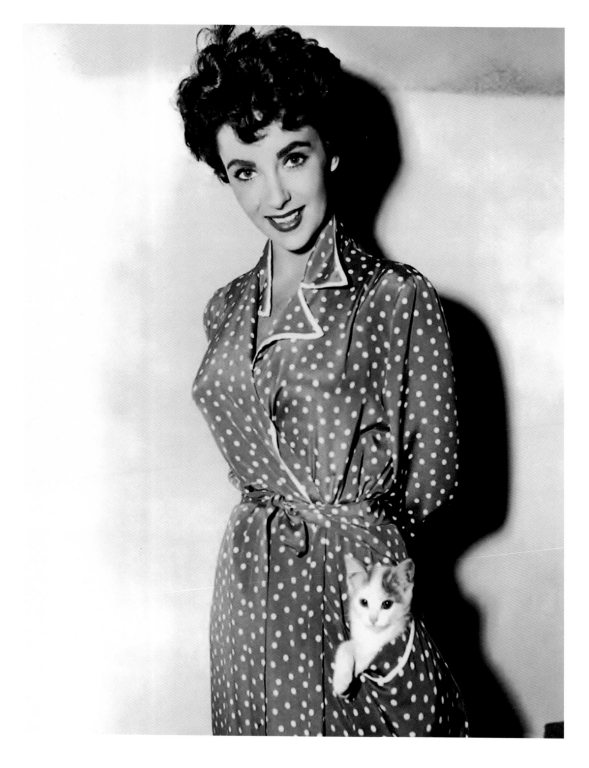

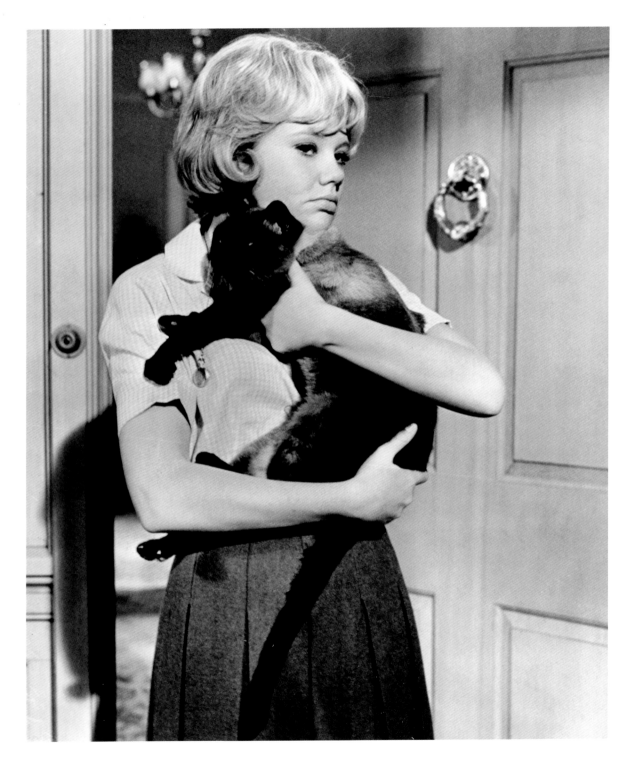

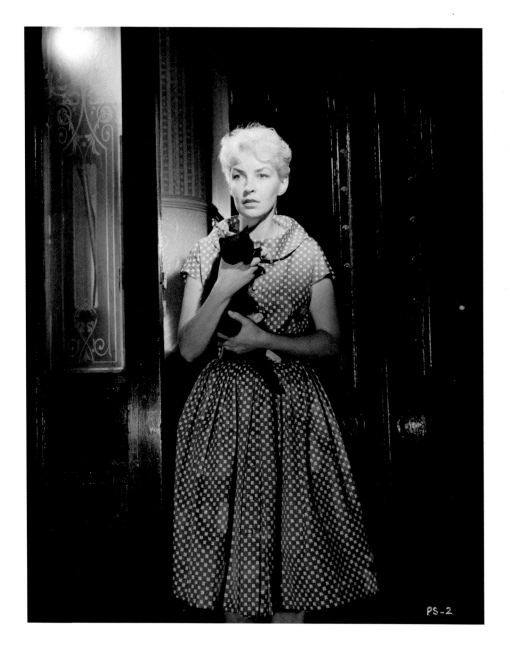

PS-2

Hayley Mills, Walt Disney Productions, 1965

Mills gives DC the cat a hug in this scene from
Disney's suspense-comedy *That Darn Cat*

Odile Versois, United Co-Productions, 1958

With concern written all over her face, Versois
desperately holds on to a kitten, a rare symbol
of innocence in *Passport To Shame*, a British
exploitation drama about prostitution and the
white slave trade. The tag line for the film was
'A Picture Best Understood by Adults!'
Photograph by Ray Hearne

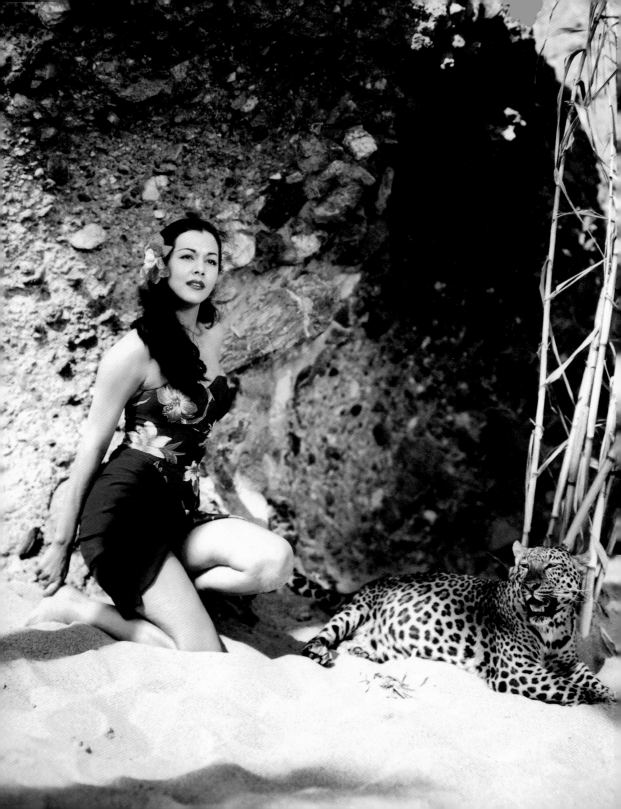

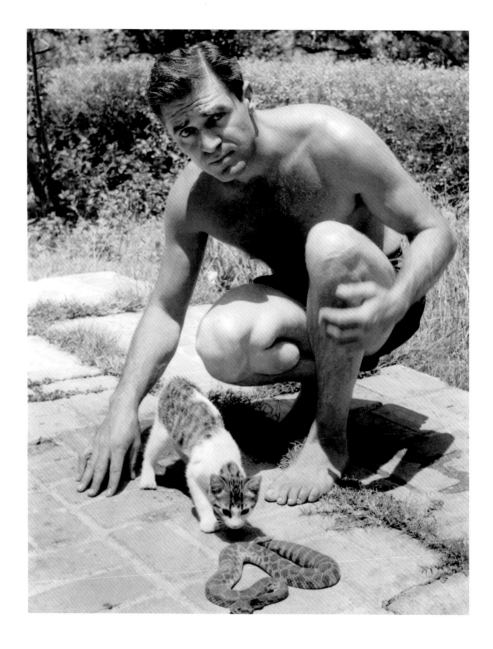

Maria Montez, Universal Pictures, 1941

Montez stars as the local beauty on a
South Pacific Island and bewitches four
seamen who drift ashore in *South Of Tahiti*.
With a pet leopard by her side, this was
one of numerous low-budget Technicolor
features released during and in the years
immediately after the Second World War

Steve Cochran, MGM, 1957

Cochran had good reason to thank his nine-
week-old kitten Terrible Touhy after the young
cat dashed in front of his owner and pounced
on a 4ft (1.2m) rattlesnake. The snake struck the
cat between the eyes knocking it to the ground.
Thankfully there was a happy ending as Terrible
Touhy was given first aid at a nearby animal
hospital and went on to make a full recovery

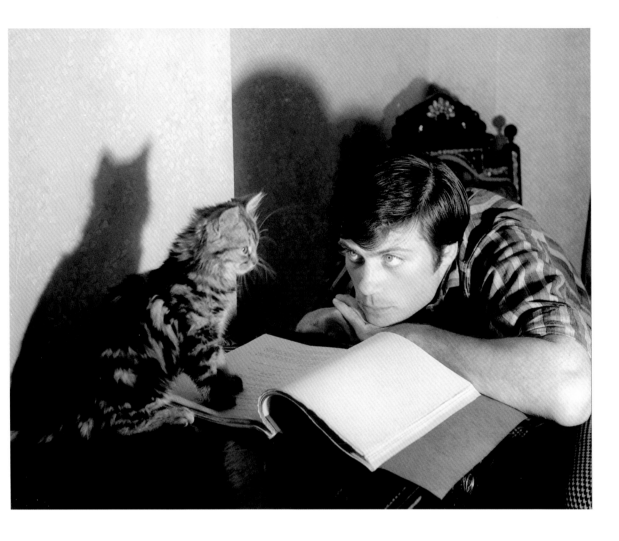

Evelyn Keyes, Paramount, 1948

Taken whilst filming Cecil B. DeMille's *Union Pacific*,
Keyes is still most famous for her role as Suellen O'Hara
in *Gone with the Wind* (MGM, 1940), as well as for the
many well-known husbands and lovers she had

Oliver Reed, Hammer Film Productions, 1961

Watched by his cat Felix, Reed studies the script
for the horror film *The Curse of the Werewolf*.
Reed's son Mark recalled after his father's death
that 'He never passed a cat without stroking it'

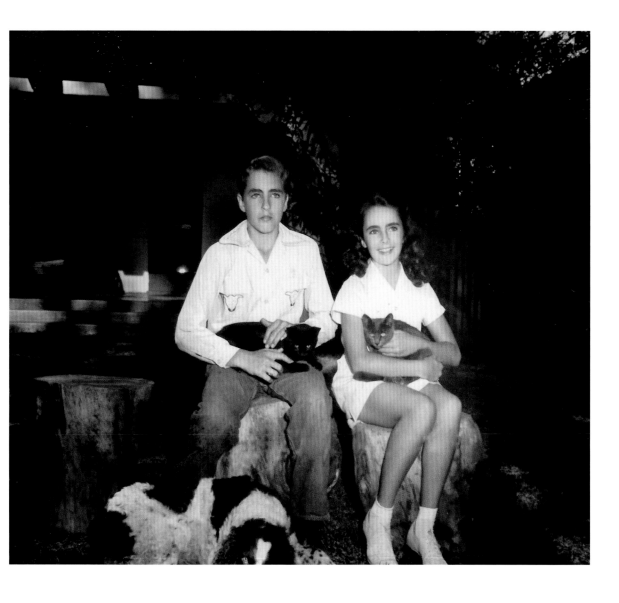

Rhonda Fleming, Selznick International Pictures, 1945

Teaching a cat new tricks. This was the year that Fleming starred alongside Ingrid Bergman and Gregory Peck in Hitchcock's *Spellbound*

Elizabeth and Howard Taylor, 1944

Throughout her life Taylor had a deep affection for all animals and is seen here with her brother and three of the family pets

Anita Ekberg, Universal International Pictures,
c.1952

Following her victory in Miss Sweden 1950, Ekberg
travelled to the United States to compete for the
Miss Universe title. Although she did not win, as one
of six finalists, she did earn a contract with UIP.
Ekberg is photographed here in an early publicity
shot with a kitten perched on her shoulder

Lilli Palmer, Warner Bros, 1946

The wife of Rex Harrison, Palmer starred
alongside Gary Copper in *Cloak and Dagger*.
She is seen here in between takes playing
with a black cat who for several years made
its home on the studio lot, becoming a firm
favourite with many Warner Bros employees in
the mid-1940s

Stewart Granger, MGM, 1954

Holding a kitten aloft in the year he
made *Green Fire* with Grace Kelly.
At home he and his wife, the actress
Jean Simmons, were keen owners of
Siamese cats

Kim Novak, Columbia Pictures, 1959

Photographed at home with one of
the many Siamese cats she owned
during her lifetime

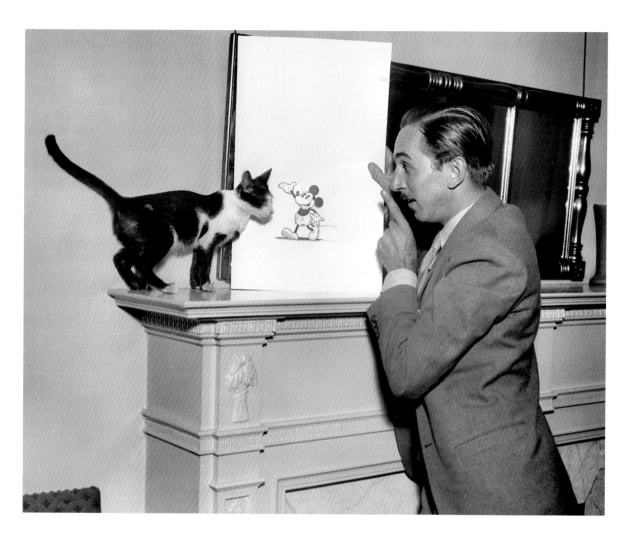

Walt Disney, 1961

Walt Disney attempts to coax a reaction
from his cat by presenting an image of
Mickey Mouse to his feline friend

Hayley Mills and Dean Jones, Walt
Disney Productions, 1965

On set with one of the traditional Seal-
Point Siamese cats who collectively
played DC in *That Darn Cat*

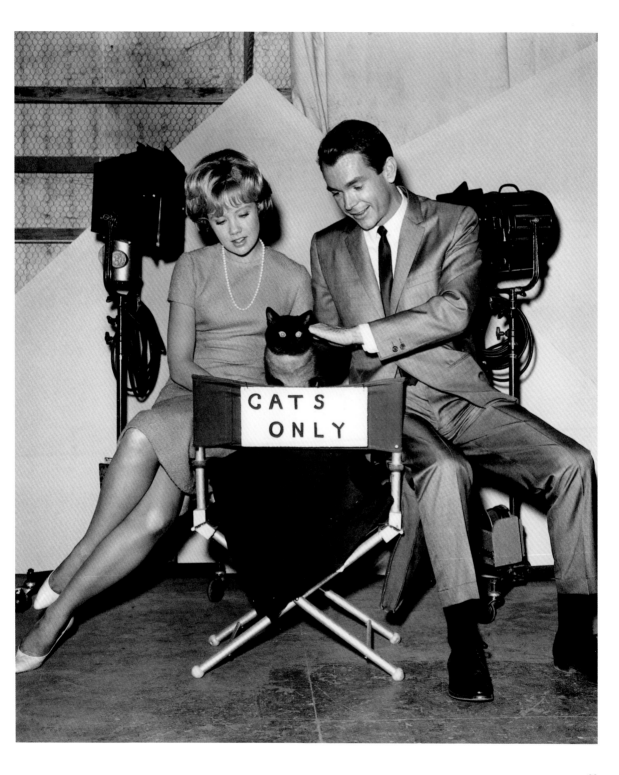

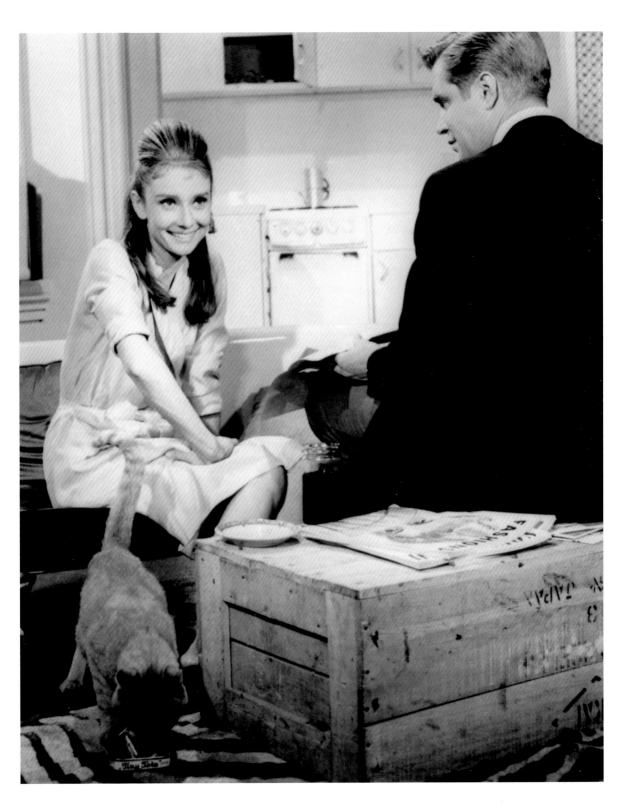

Audrey Hepburn and George Peppard,
Paramount Pictures, 1961

Animal actor Orangey stars as 'Cat',
Holly Golightly's 'poor slob without a
name' in *Breakfast at Tiffany's*.
Hepburn obviously had a natural
affinity with cats as she went on to say
that the scene where she throws 'Cat'
into the rain from a New York cab was
the most distasteful thing she ever had
to do on film

Margaret Sullavan, Columbia Pictures, 1950

On the set of *No Sad Song for Me*, Sullavan sits with the family
pet. In this sentimental melodrama, Sullavan stars as a woman
who encourages her husband to find a replacement wife
when she finds out she only has ten months to live
Photograph by Van Pelt

Natalie Wood, Columbia Pictures, 1950

Twelve-year-old Natalie Wood plays
the role of the daughter in *No Sad
Song For Me*. Wood is seen here on set
with the cat that played the family pet
in the film

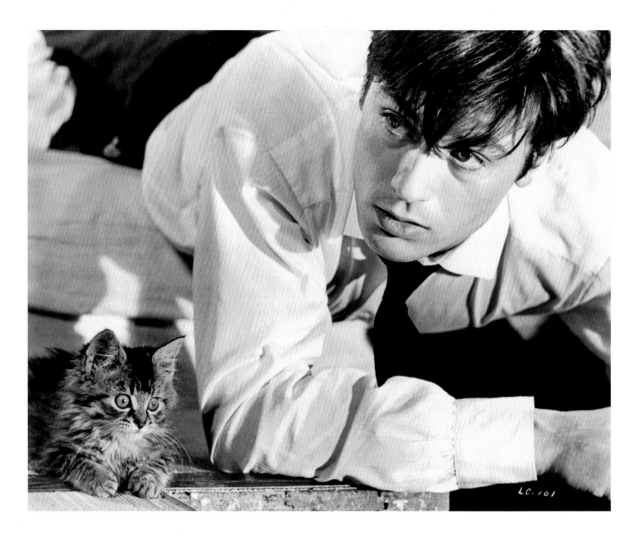

Alain Delon, MGM, 1964

Delon comes down to the level of this wide-eyed kitten in *Joy House*, a thriller set on the French Riviera that also starred Jane Fonda

Jane Fonda, Warner Bros, 1971

Fonda won an Oscar for her role as Bree Daniels, a New York City call girl who becomes the key figure in a detective's search for a missing man in *Klute*. Fonda's character is memorably seen using a spoon to eat her pet cat's food straight from the tin in one scene

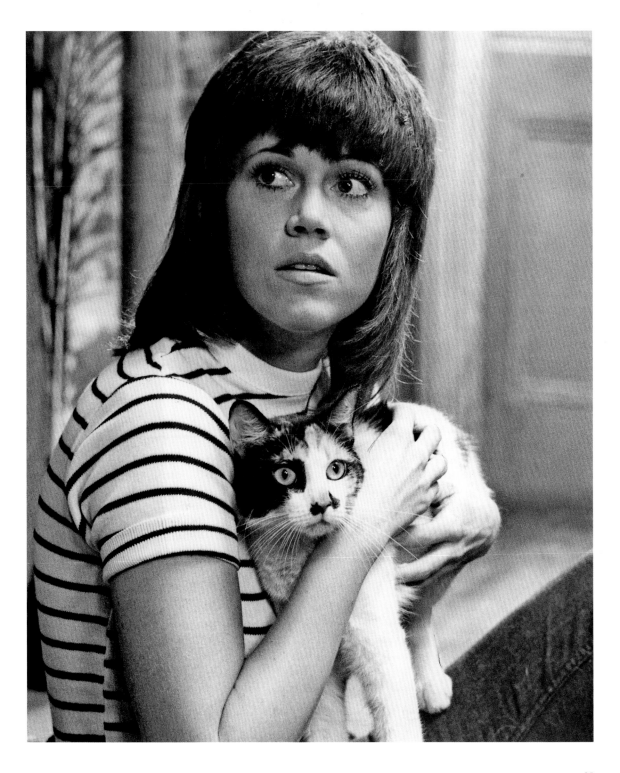

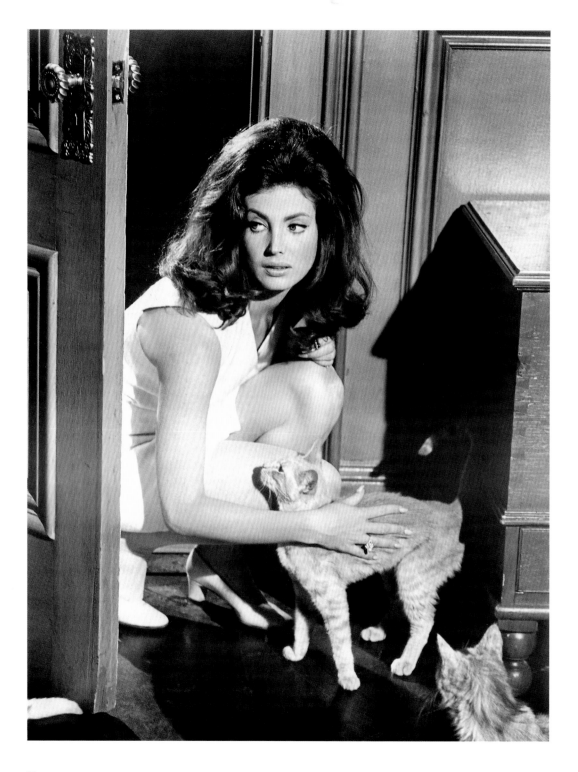

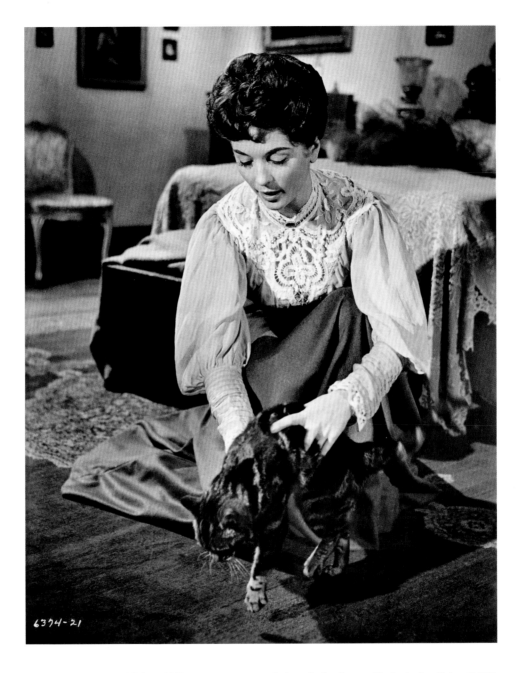

6394-21

Gayle Hunnicutt, Universal Pictures, 1969

In *The Eye Of the Cat*, a man and his girlfriend
attempt to defraud his wealthy aunt when they visit
her mansion. Unfortunately for the two conspirators,
the house is overrun by vengeful cats who seem
only too aware of their plans

Barbara Shelley, Hammer Film Productions/Universal, 1961

A staple of the British horror film, Barbara Shelley plays
Beth Venable in *The Shadow Of The Cat*. She is seen here
with Tabatha, a family pet hell bent on gaining revenge
after witnessing the murder of her mistress and Beth's
aunt Ella

Marilyn Monroe, 20th
Century Fox, 1961

On set during the filming of
John Huston's fabled *The
Misfits*. Monroe starred
opposite Clark Gable;
sadly it was to be the last
film either of the stars
completed

Marlon Brando, c.1955

Brando obviously loved
animals – he kept both
cats and dogs, as well as a
raccoon called Russell,
which was a present from
his mother

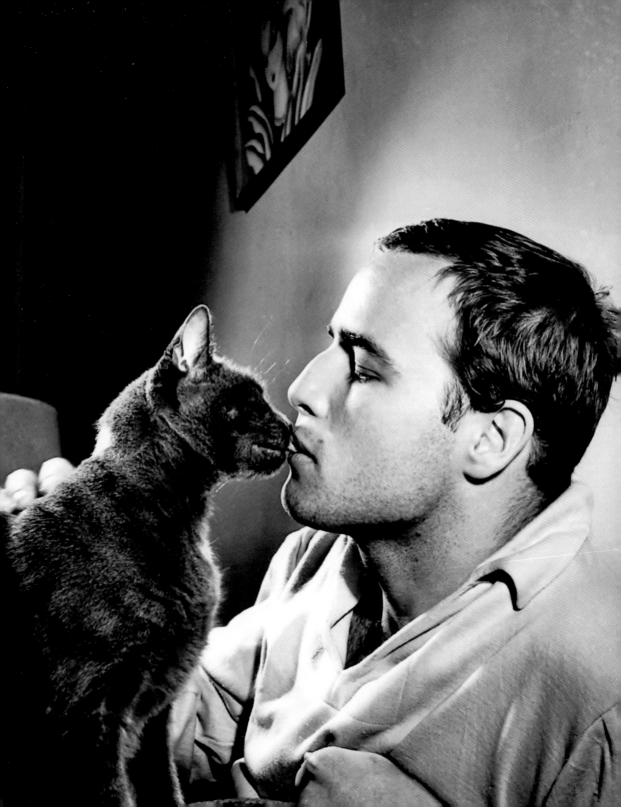

Greer Garson, MGM, 1941

The British actress and her pet cat relax in
their Hollywood home just two years after
being discovered by Louis B. Mayer whilst
he was scouting for talent in London

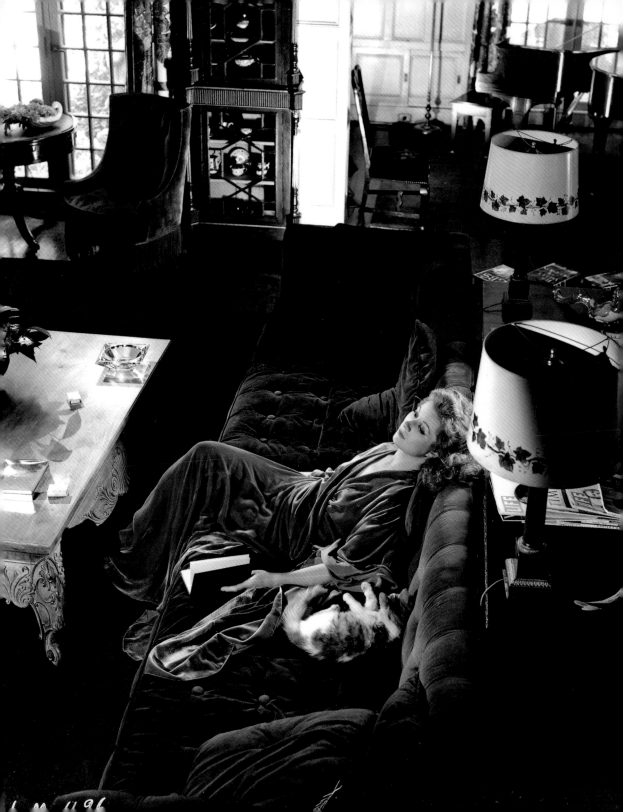

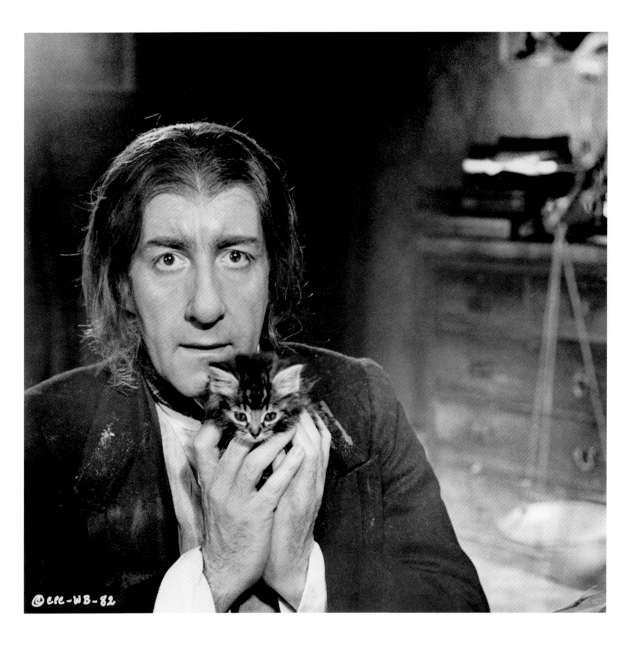

@ ere-WB-82

Peter Sellers, Salamander Film Productions, 1966

Sellers plays the role of the eccentric Dr Pratt in
the black comedy *The Wrong Box*. Besides the
numerous cats and kittens that overrun his
office, the cast list reads like a *Who's Who* of
classic comedy actors from the era

Ann-Margret, Universal Pictures, 1964

Ann-Margret plays with a Siamese kitten presented to her
during filming of *Kitten With a Whip*. In the film she plays a
runaway from juvenile detention who causes havoc in the
life of a politician after she moves into his house against his
wishes and forces him on a road trip to Mexico

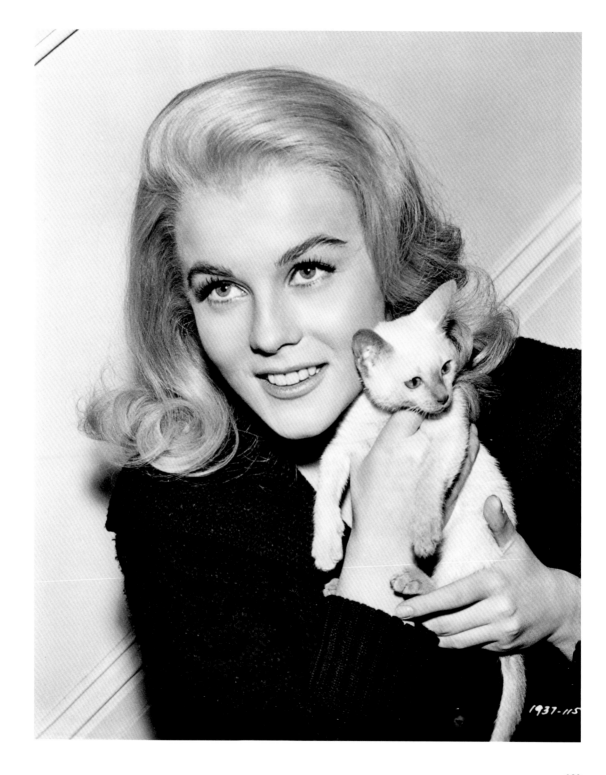

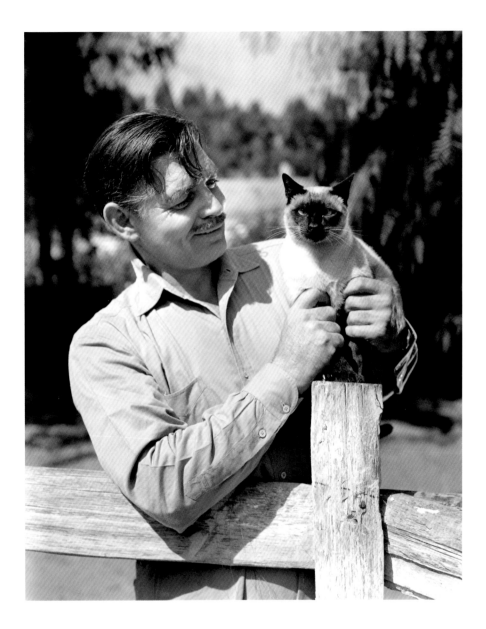

Clark Gable, MGM, 1945

Gable poses with one of the cats that lived on his 22-acre ranch in the San Fernando Valley. The actor had just finished filming *Adventure* when this publicity photograph was shot. It was his first credit following his service in the Army Air Corps and MGM promoted the film with the line 'Gable's back and Garson's got him'. Despite audiences at first lining up to see his return, the film received poor reviews and proved to be a commercial failure. Gable was so disappointed with the finished product that it was over a year before he agreed to act again

Ann Rutherford, MGM, 1941

With the prize cat Sonny Boy, a shaded silver Persian who competed at the California Annual Cat Club Show. Rutherford famously starred as Scarlett O'Hara's sister, Carreen, in the 1939 production of *Gone With the Wind*

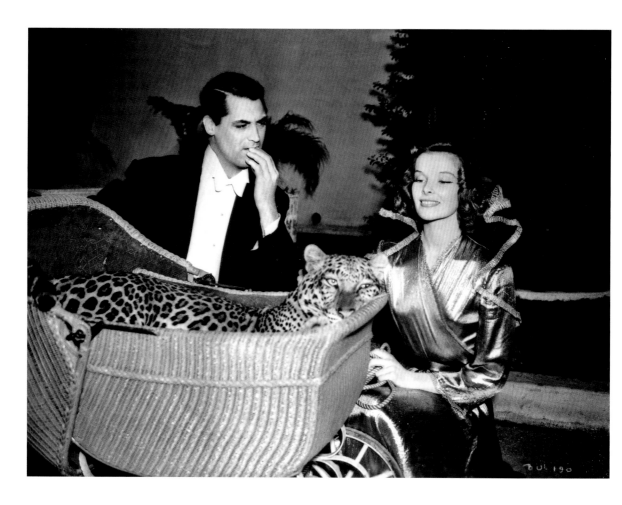

Cary Grant and Katharine Hepburn, RKO, 1938

Nissa stars as the eponymous Baby in RKO's comedy hit
Bringing Up Baby. The leopard was particularly fond of
Hepburn and would often be found in the company of
the actress during breaks in filming; Grant, on the other
hand, kept his distance and insisted on a puppet being
used in certain scenes

Cecil B. DeMille, Paramount Pictures, 1956

As the producer of one of Hollywood's greatest historical
epics, DeMille sits in his office with one of the 15,000 animals
he used for shooting some of cinema's most ambitious scenes
in *The Ten Commandments*. The film cost $13 million dollars to
make but for years was one of the most successful movies of
all time, ranking second only to *Gone With the Wind*

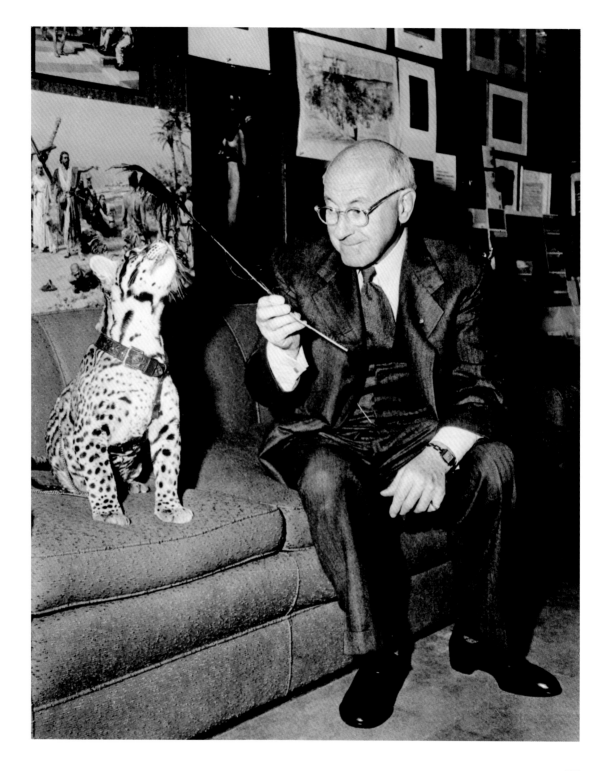

Mary Martin, Paramount Pictures, 1941

Martin holds the ship's cat aloft in the romantic comedy *New York Town*

Bella Darvi, 20th Century Fox, 1954

Playing the role of the courtesan Nefer in *The Egyptian*. As with her film career, Darvi's real life was full of drama and tragedy. Born in Poland and brought up in France, she was interned in the Osnabrück (Neuengamme) and Auschwitz concentration camps following Germany's invasion of France in 1940. Having survived these ordeals, she was 'discovered' and brought to Hollywood. Things did not go well, however, and following various scandals she retreated to Europe where she committed suicide, burdened by debts

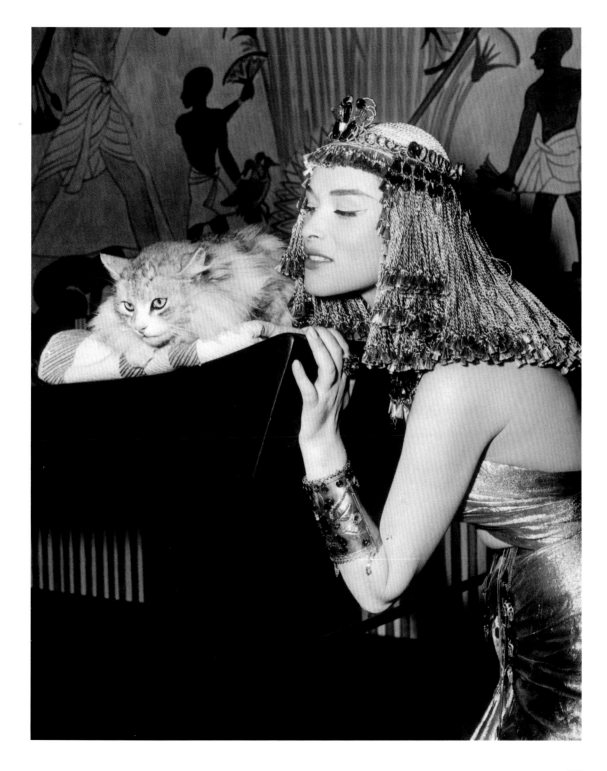

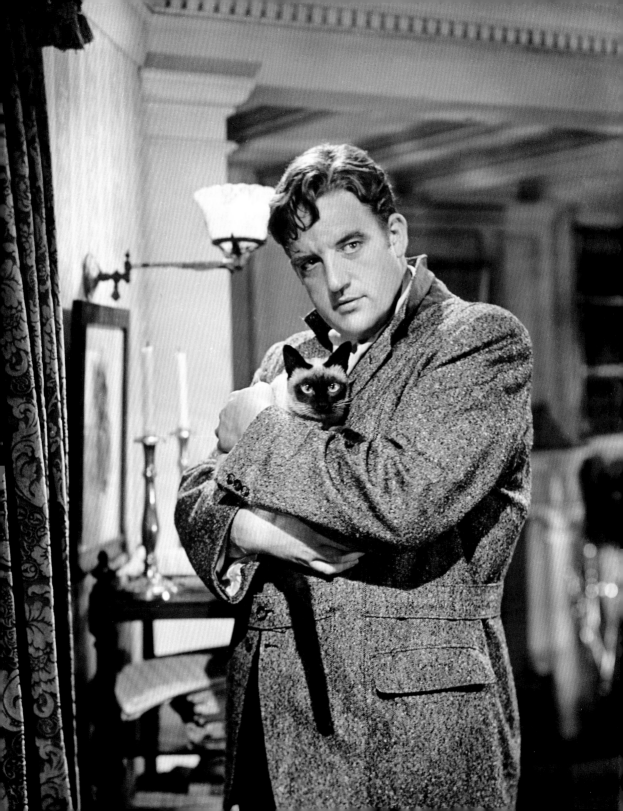

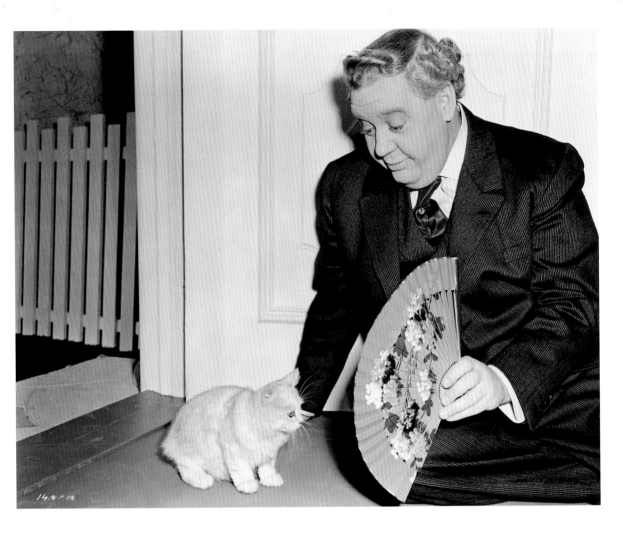

Laird Cregar, 20th Century Fox, 1945

Cregar holds a Siamese cat during the filming of *Hanover Square*. The film was Cregar's last – he died shortly after filming finished due to complications brought on by a crash diet devised to make him lose weight so he could play a broader range of roles

Charles Laughton, Universal Pictures, 1944

Laughton teases a kitten with a fan in *The Suspect*, a thriller set in Victorian London. This playful shot helped to reinforce Laughton's character in the film as a decent man, despite being accused of murdering his thoroughly pernicious wife

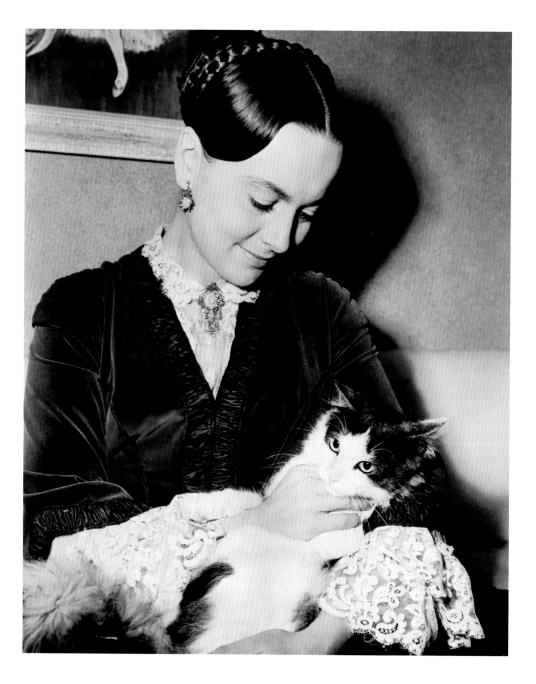

Olivia de Havilland, Paramount, 1949

De Havilland won her second Oscar for Best Actress in a
Leading Role in *The Heiress*. She is photographed here during a
break in filming. The film won a further three Academy Awards
for Art Direction, Costume Design and Musical Scoring

Janet Blair, Columbia Pictures, 1945

Relaxing with a cat in the year she
starred alongside Rita Hayworth in
Tonight and Every Night

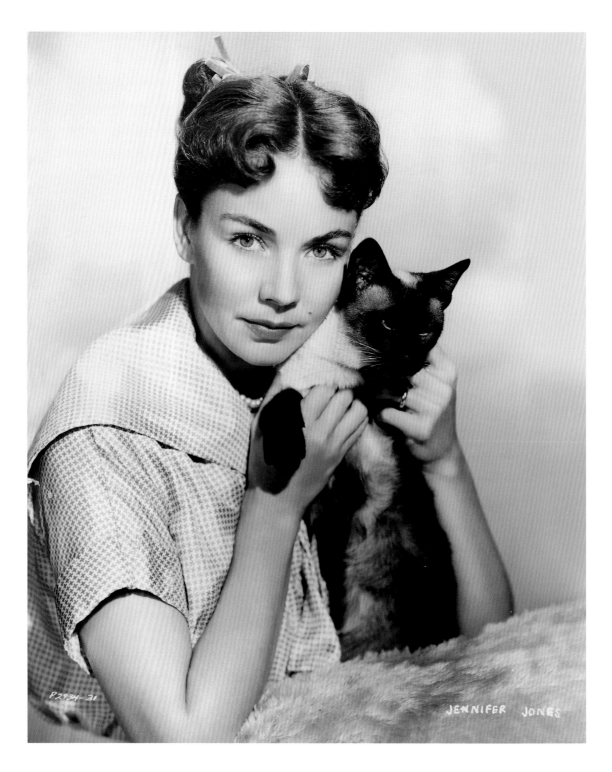

JENNIFER JONES

P2924-31

P2574-79

Jennifer Jones, Paramount Pictures, 1952

Used to publicise her role in *Carrie*, Oscar-winning actress Jennifer Jones is seen here holding a Siamese cat. In the film she starred opposite Laurence Olivier, who at the time was married to Vivien Leigh, herself a very keen owner of numerous Siamese cats

Bob Hope and Paulette Goddard, Paramount Pictures, 1939

With a cat hanging limply from her hand, Goddard appears amused by something the comic actor Bob Hope has said during the filming of *The Cat and the Canary*

Margaret Lockwood and Ronald Shiner,
Herbert Wilcox Productions, 1954

On their way to Singapore with the
ship's cat in *Laughing Anne*

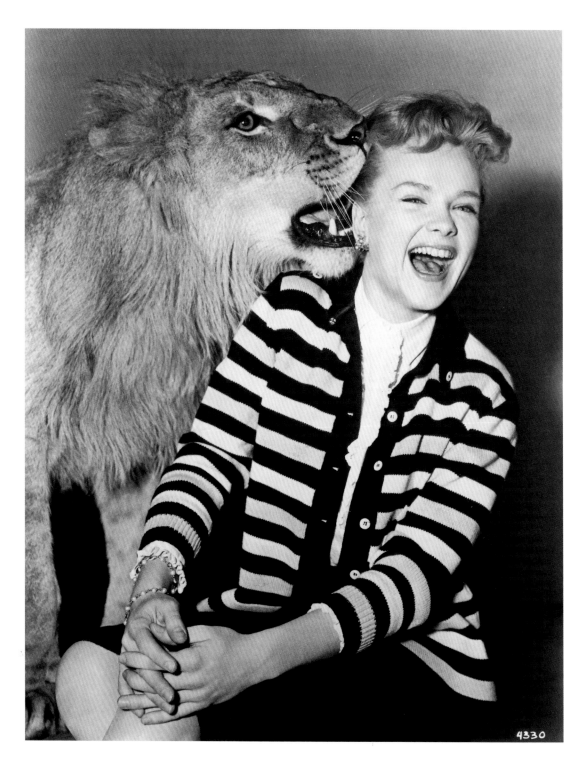

4330

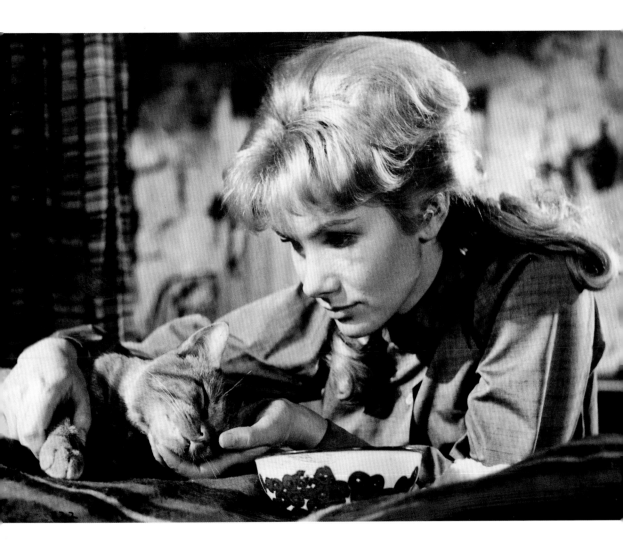

Anne Francis, MGM, 1956

Francis appears remarkably
relaxed given the attention she is
receiving from George, the sixth
MGM lion, who made his debut in
the opening credits of her movie,
Forbidden Planet

Susan Hampshire, Walt Disney Productions, 1964

Hampshire plays the role of the mysterious Lori MacGregor
in *The Three Lives of Thomasina*, a story of a cat whose
resurrection from near death helps heal the fractured
relationship between a widowed father and his daughter.
Filming was held up for several days when one of the cats
used to play Thomasina refused to perform a stunt for
which she had been specifically trained

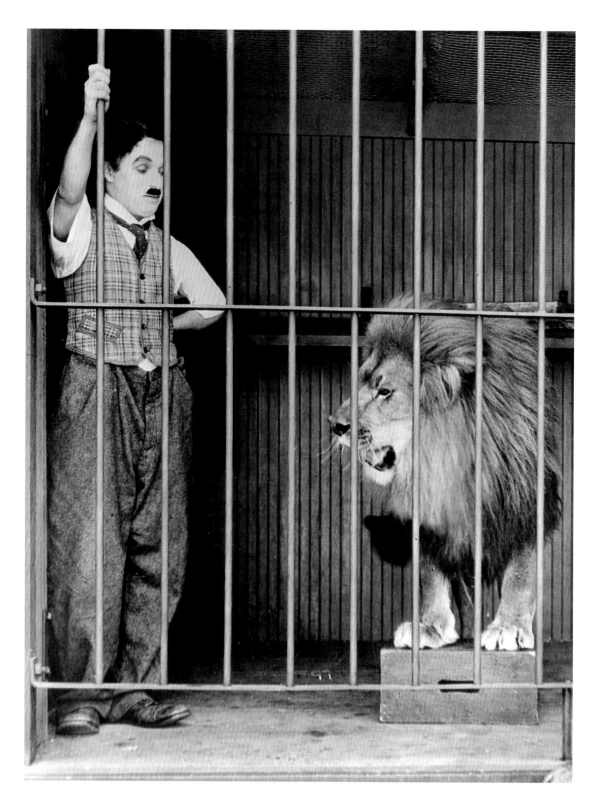

Charlie Chaplin, Charles Chaplin
Productions/United Artists, 1928

With a particular talent for comedy, and a long
list of credits to his name, Numa was considered
to be the best-trained lion in Hollywood at the
time and therefore a natural choice to star
alongside Chaplin in *The Circus*, the eighth
highest grossing silent film in cinema history

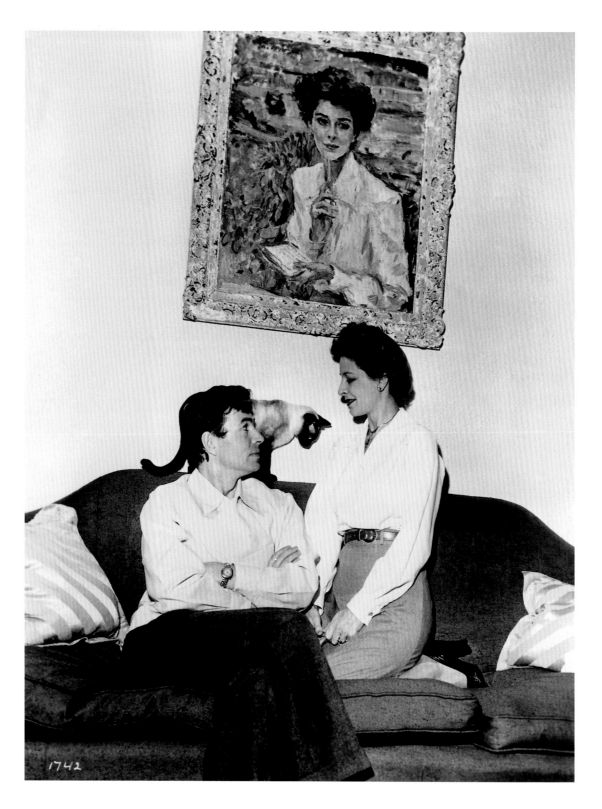

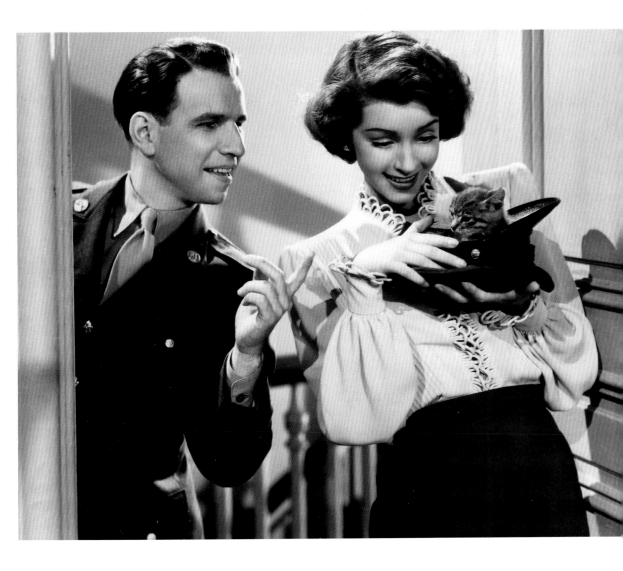

James and Pamela Mason, MGM, 1949

Seated below a portrait of Mrs Mason, the couple had only recently become residents of Hollywood when this photograph was taken. Not prepared to leave England without their beloved cats, they eventually purchased Buster Keaton's former mansion and whilst renovating discovered several reels of film – previously thought lost – by the famous silent movie star

Hume Cronyn and Marsha Hunt, MGM, 1946

A scene from *A Letter for Evie*, the story of a GI who finds himself in a predicament after responding to a letter intended for a more handsome and muscular comrade. Having featured in over fifty films in the fifteen years leading up to the end of the 1940s, Hunt's career was subsequently seriously affected by her McCarthy-era blacklisting in the early 1950s

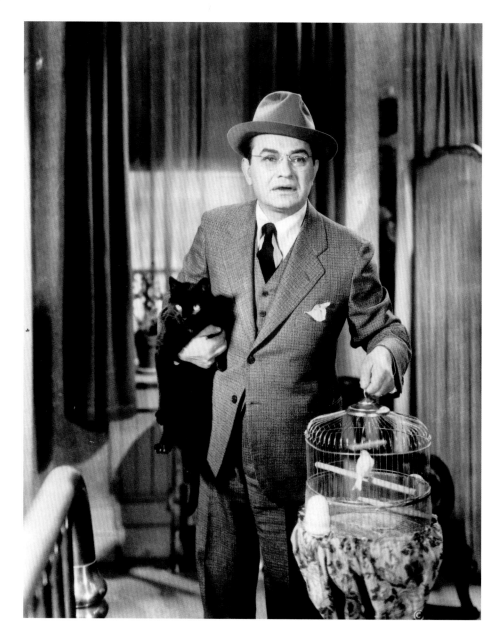

Edward G. Robinson, Columbia Pictures, 1935

With his cat Abelard and his canary Heloise, Robinson plays a
mild-mannered clerk mistaken for a notorious gangster in *The
Whole Town's Talking*. With growing indignity surrounding the
perceived vulgarity of gangster movies, it was only due to its
comedy content that the film avoided falling foul of the
code William Hays drew up to enforce prohibition on
subversive content in film – the principles of which went on to
govern film narrative in Hollywood at the time

Piper Laurie, Universal International Pictures,
1953

Decorating her bedroom for the festive
season in *Mississippi Gambler*, Laurie
entwined a red California Poinsettia in her
ruffled window curtains and completed the
colour scheme by tying red satin bows
around the necks of her two grey Persian
kittens

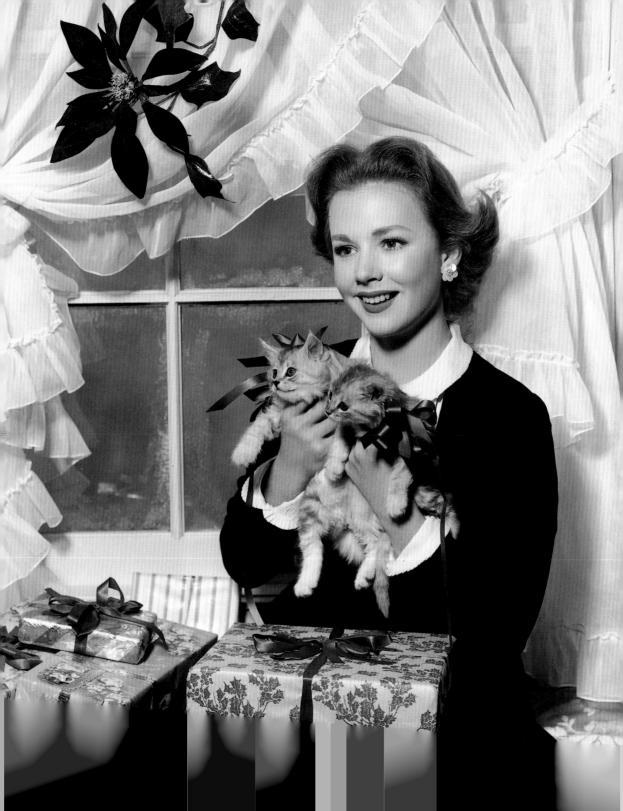

Keenan Wynn, Janet Leigh and Tony Curtis, MGM, 1952

Disproving the theory that only dogs like sticks. Leigh
and Wynn starred alongside Fagan the lion in *Fearless
Fagan* and are joined here by Leigh's husband, the
actor Tony Curtis, outside the MGM sound stage.
Fagan's performance in the film was widely praised,
although it was Jackie, MGM's trademark lion and
stand-in for some scenes, who went on, somewhat
unfairly, to win a PATSY (Picture Animal Top Star of the
Year) award for the film in 1953

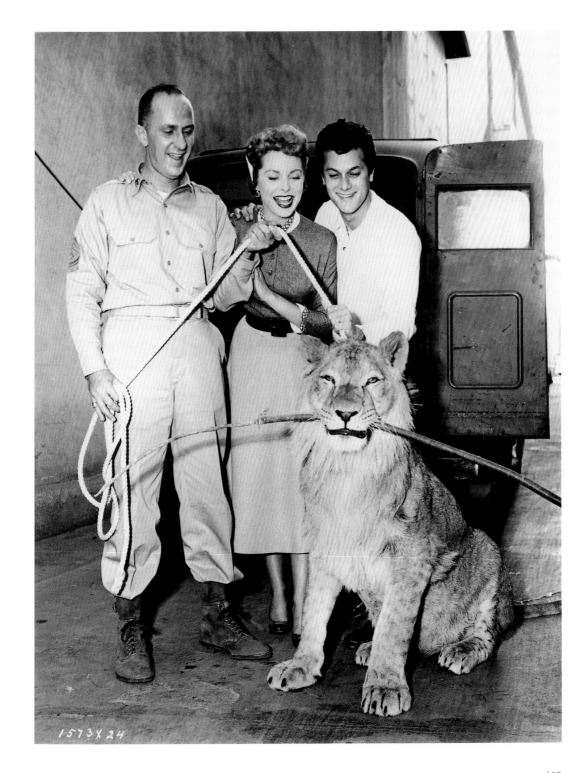

1573X24